W9-CTW-101

DATE DUE

~~OC 30 98~~			
~~AP 22 03~~			
~~MR 15 05~~			
~~AP 5 05~~			

DEMCO 38-296

Masterpieces
of the J. Paul Getty Museum

ILLUMINATED MANUSCRIPTS

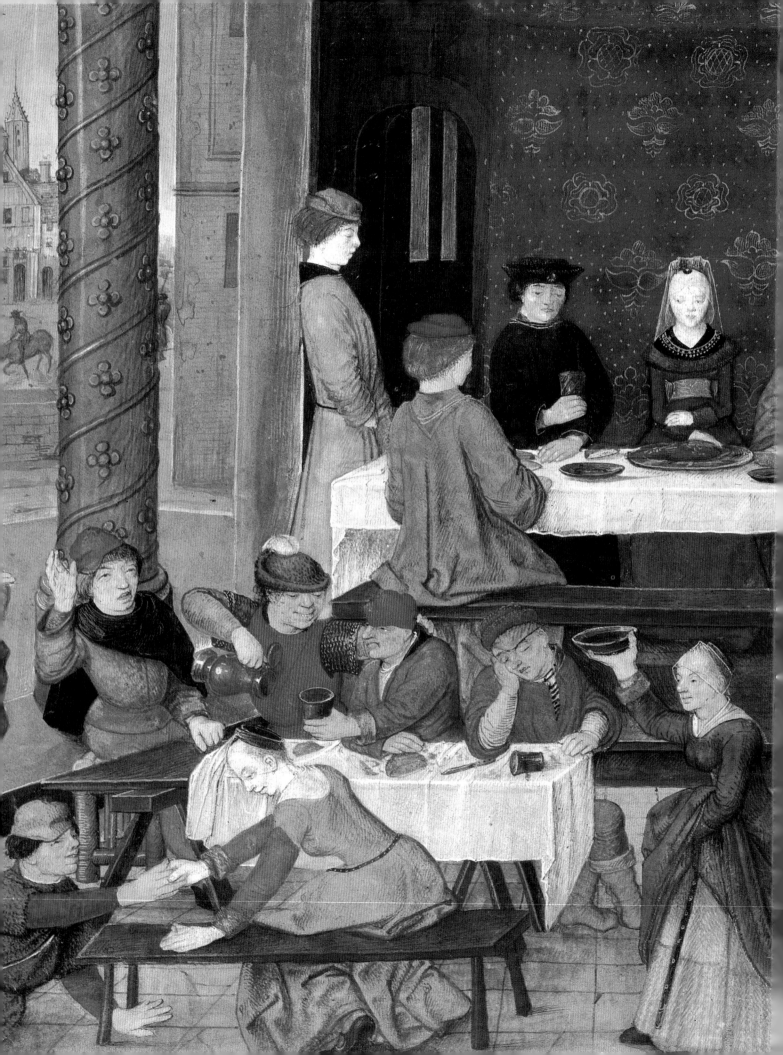

Masterpieces
of the J. Paul Getty Museum

ILLUMINATED MANUSCRIPTS

Los Angeles
THE J. PAUL GETTY MUSEUM

Riverside Community College
Library
OCT '98 4800 Magnolia Avenue
Riverside, CA 92506

ND 3125 .J2 1997

J. Paul Getty Museum.

Masterpieces of the J. Paul
Getty Museum. Illuminated

Master of the Dresden Prayer Book,
The Temperate and the Intemperate
[detail] (See no. 41)

At the J. Paul Getty Museum:

Christopher Hudson, *Publisher*
Mark Greenberg, *Managing Editor*
Mollie Holtman, *Editor*
Suzanne Watson Petralli, *Production Coordinator*
Charles Passela, *Photographer*

Text prepared by Thomas Kren, Elizabeth C. Teviotdale,
Adam S. Cohen, and Kurtis Barstow

Designed and produced by Thames and Hudson
and copublished with the J. Paul Getty Museum

© 1997 The J. Paul Getty Museum
1200 Getty Center Drive
Suite 1000
Los Angeles, California 90049-1687

Library of Congress Card Number 97-070932

ISBN 0-89236-445-9

Color reproductions by CLG Fotolito, Verona, Italy

Printed and bound in Singapore by C.S. Graphics

DIRECTOR'S FOREWORD

The collection of illuminated manuscripts covered by this book, like so much else about the Getty Museum, is a new creation, having been formed only in the past fifteen years. When J. Paul Getty's will was opened in 1976, it was discovered that he had made a seven hundred million dollar bequest to his museum. A small institution with a narrow, uneven collection was suddenly in a position to expand in any direction its trustees chose. During the six years in which lawsuits prevented them from using the legacy, new possibilities were explored by the Getty Trust for services to scholarship, conservation, and arts education, as well as for building up a much more important museum.

When I decided to come to the Getty in 1983, one idea for expanding the Museum's collection was already in the works: the acquisition *en bloc* of the Ludwig Collection of illuminated manuscripts. Getty's own interests as a collector had been confined to antiquities, decorative arts, and paintings, and the Museum had not strayed outside those boundaries. These illuminated manuscripts offered a chance not only to annex the Middle Ages and early Renaissance, but also to show the public a vast array of brilliantly preserved pictures that would never be rivaled by later purchases of panel paintings.

At the urging of Thomas Kren, then Associate Curator of Paintings, the acquisition was made. Soon we created the Department of Manuscripts with Dr. Kren as its first curator; a staff was recruited, a study room fitted out, and an ambitious program of activities launched. These have included regular exhibitions, catalogues of the permanent collection, scholarly studies, and exhibition catalogues—taken together, a large achievement for such a young department. At the same time, new collections of drawings, sculpture, and photographs were also formed; these have tremendously enriched our visitors' experience in the past dozen years.

Added to the Ludwig Collection have been purchases of manuscripts and cuttings, among them many of our greatest works. These will be published in a catalogue by Thomas Kren scheduled to appear in the near future.

To the writers of this book—Thomas Kren, assisted by Elizabeth C. Teviotdale, Adam S. Cohen, and Kurtis Barstow, all of the Department of Manuscripts—I am very grateful.

Works of art are always distorted by reproductions in books, which shrink them into patches of printer's ink. The distortion is least in the case of manuscript illumination. We hope that turning the pages of this book will offer the reader at least some of the joys of close contact with the originals and will be an incentive for a visit to the new Getty Museum, where every day many of our finest manuscripts can be seen.

JOHN WALSH
Director

INTRODUCTION

The Getty Museum's endeavor to create a collection representative of the history of European manuscript illumination is atypical. Despite their important place in the history of European art, illuminated manuscripts have not found their way into art museums as most other portable artistic media have. Relatively few of the art museums created during the nineteenth and twentieth centuries in Europe and America have actively collected illuminated manuscripts. This is in part because these lavish books have generally passed from private libraries into public ones. Many of the great imperial, royal, ducal, and even papal manuscript collections became components of national and state libraries. This pattern has generally held into the twentieth century. The American collector J. Pierpont Morgan (1837–1913) gave generously of his splendid holdings in medieval art to museums, principally to the Metropolitan Museum of Art in New York. But his extraordinary collection of medieval and Renaissance illuminated manuscripts was not included in that gift, instead becoming part of the private library that carries his name. Therein resides the finest collection of medieval painting in America. The greatest museum repository of illuminated manuscripts, the British Museum, London, handed over its illuminated books to the newly formed British Library only twenty-five years ago.

Conversely, the Metropolitan Museum of Art, with its resplendent collection of medieval art, has acquired only a handful of illuminated codices (albeit magnificent and important ones) along with a select group of leaves. It has refrained from collecting illumination actively or systematically. Only two people envisioned collecting illuminated manuscripts within the context of encyclopedic art collections: Henry Walters, whose collections formed the basis for the Walters Art Gallery in Baltimore, and William Milliken, Director and Curator of Medieval Art at the Cleveland Museum of Art, with the Walters concentrating on books and Cleveland on cuttings.

The Getty Museum's collection of illuminated manuscripts owes something to both the Walters and Cleveland models. Although it became apparent early, due both to issues of cost and availability, that the modern ideal of encyclopedic collections would not be feasible at the Getty, the trustees proposed expanding the Museum's collections beyond the three areas to which J. Paul Getty (1892–1976) had limited himself. Medieval art was one of the targeted fields.

The collection was begun with the purchase of 144 illuminated manuscripts assembled by Peter and Irene Ludwig of Aachen, Germany, in 1983. The finest collection of illuminated manuscripts formed in the second half of the twentieth century, the Ludwigs' holdings were among the very few private collections of the material still intact. Their collection was selected with the advice of book dealer

Hans P. Kraus to provide a historical survey of the illuminated manuscript, representing a broad time frame and range of schools along with great variety in the types of books. This purchase of the Ludwig manuscripts not only added a number of masterpieces of medieval and Renaissance art to the Museum's collection but also complemented that of European paintings, extending the coverage of the history of painting back to the ninth century. Since then the department has added to these holdings selectively, filling gaps and building on strengths where possible.

The following pages display illuminations from the Museum's finest manuscripts, including a number of fragmentary ones. The selections are arranged roughly chronologically in a survey that reflects broadly the strengths of the collection. The book commences with a Gospel lectionary from the late tenth century, produced in one of the great monastic scriptoria of the Ottonian era. It concludes with an unusual Model Book of Calligraphy with scripts by Georg Bocskay, imperial court secretary to the Hapsburg emperor Ferdinand I (r. 1556–64), and illuminations by Joris Hoefnagel, a court artist for the emperor Rudolf II (r. 1576–1612). The six hundred years that separate these two books witnessed tremendous social and cultural changes, including the transition from monastic to lay workshops of book production, an explosion in book collecting resulting in the formation of the great court libraries, the growth of aristocratic patronage, and the emergence of bourgeois patronage.

By way of illustration, the deluxe Gospel book enjoyed its widest appeal in Western Europe only until the twelfth century, but reigned for a much longer period in the eastern Mediterranean and Christian Near East. Although it was unimportant before the thirteenth century, the book of hours found an audience of lay people whose scope would have been unimaginable in the earlier era, and so it became the most popular book of the later Middle Ages and a primary vehicle for illuminators' artistic innovations in Western Europe. Other consequential changes over the course of the Middle Ages and Renaissance include the rise of vernacular literature and translations along with an expansion in the types of works that were deemed appropriate to illuminate; a new level of self-consciousness on the part of artists; and the introduction of printing from movable type that would result eventually in the hegemony of the printed book.

The commentaries herein seek to highlight some of these changes. The reader will find, for instance, that in the later period we not only have a broader range of titles but generally know more about both the artists and the patrons. Whenever possible, the authors of the entries have provided a wider artistic or historical context for the manuscript; inevitably, where the collection is stronger, more connections are drawn among the examples.

The selection of objects in this book surveys the cream of the collection, but it is not a proper historical survey. Rather, it reflects the imbalances within the Museum's holdings. The Ludwig manuscripts enjoy particular riches among German illumination of the eleventh to the fifteenth centuries and in late medieval Flemish manuscripts. The Getty has added examples to these areas over the years while actively developing the collection of later medieval French illumination, an area in which the Ludwigs acquired only a few manuscripts. At the same time certain schools from the beginning of the tradition (Early Christian to Carolingian) remain thinly represented or absent. But part of the challenge of collecting as well as the pleasure is the discovery of the rare and unexpected. The goal of assembling a representative and balanced history of the art of manuscript illumination is doubtless unattainable. Nevertheless, it focuses our efforts to improve the overall quality and character of the Getty's small collection. Perhaps time, perseverance, and fortune will permit us to fill some of the lacunae.

THOMAS KREN
Curator of Manuscripts

NOTE TO THE READER

The following types of illuminated manuscripts appear in this book:
 untitled books
 titled books
 groups of leaves from an identifiable manuscript
 miniatures and historiated initials from an identifiable manuscript
 miniatures from an unidentifiable manuscript
 miniatures that may or may not come from a manuscript.

In the case of untitled books, generic titles are used (e.g., book of hours).

Titled books are cited by author and title (in the original language) or by title alone.

In the plate captions, the artist's name is given when known. The medium for all of the painted decoration in the manuscripts featured in this book is tempera colors, sometimes used together with gold leaf, silver leaf, or gold paint. The support is customarily parchment, although the sloth in Ms. 20 (no. 53) is painted on paper.

We cite the Bible according to the Latin Vulgate version.

1 Gospel Lectionary
 Saint Gall or Reichenau,
 late tenth century

212 leaves, 27.7 x 19.1 cm
(10¹⁵⁄₁₆ x 7⁹⁄₁₆ in.)
Ms. 16; 85.MD.317

Plate: Decorated Initial *C*, fol. 2

The reconstitution of Charlemagne's Holy Roman Empire under Otto I in 962 ushered in a new era of luxury art production. The imperial dynasty of Saxon kings in Germany dominated the European political landscape from the mid-tenth into the eleventh century. Over the course of roughly one hundred years some of the most sumptuous illuminated manuscripts of the Middle Ages were produced in the Ottonian realm.

The lectionary is a collection of the Gospel selections to be read during the mass. As in many such liturgical manuscripts, the most important feast days are marked by pages filled with large and elaborate decorated initials (called incipit pages) to introduce the readings. This ornate *C* begins the Latin of Matthew 1:18, "When Mary his mother was espoused to Joseph . . ." (*Cum esset . . .*), the passage read on Christmas eve.

The style of the foliate initial indicates that this manuscript was created in either Saint Gall or Reichenau (both near the modern Swiss-German border). The monasteries there were among the first centers for the production of Ottonian manuscripts, and the rich use of gold and purple in this and other works reveals the wealth possessed by such religious foundations. Reichenau in fact was noted for the creation of opulent manuscripts associated with the imperial house, while Saint Gall had a long tradition of scholarship and art production reaching back to the age of Charlemagne and beyond.

Although initials had been given prominence in earlier medieval manuscript painting, Ottonian pages display an unprecedented and remarkable formal harmony. In this characteristic example, the rectangular frame creates a clearly defined space for the initial and serves as an anchor for the golden vines that intertwine with the letter *C*. Within the frame, the brilliant gold is subtly accented by pale patches of blue and lavender with spots of orange and dark blue, all of which is contrasted with the creamy tone of the parchment. Greatly admired for their beauty and rarity, few Ottonian manuscripts are to be found in American collections, and in this respect the Getty Museum's group of four books is exceptional (nos. 1, 3–5). ASC

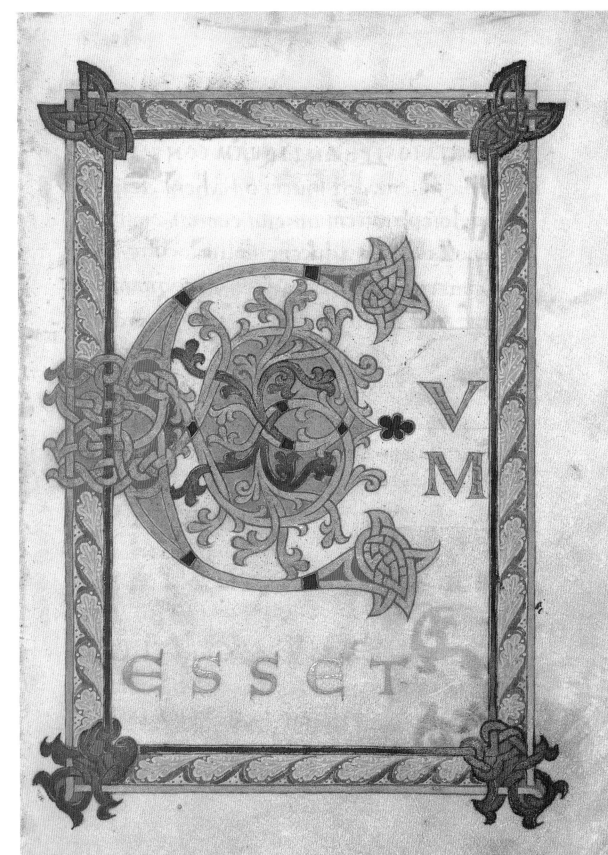

VM
esset·

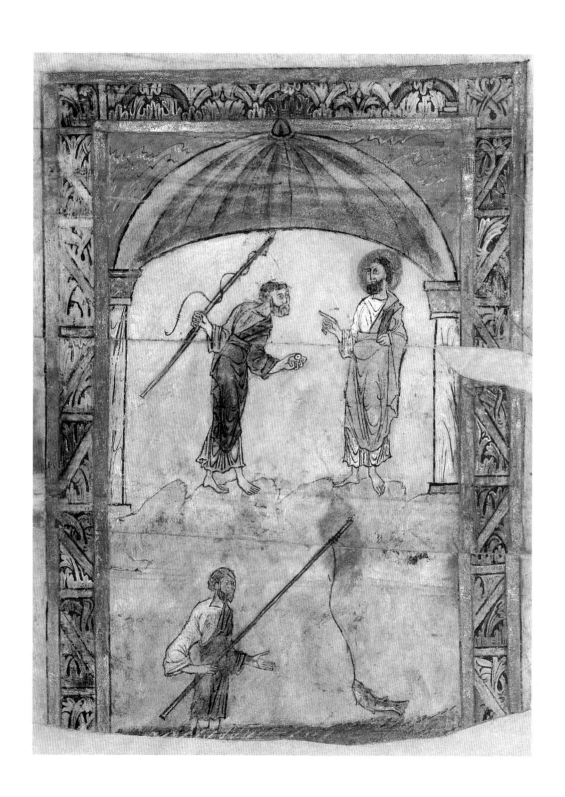

2 Two Leaves from a Gospel Book
 Canterbury (?), circa 1000

 31.3 x 20.2 cm (12⁵⁄₁₆ x 8 in.)
 Ms. 9; 85.MS.79

 Plate: *The Miracle of the Stater,* leaf 2

The Museum's two Anglo-Saxon leaves come from an illuminated Gospel book (a book containing the accounts of Christ's life written by Saints Matthew, Mark, Luke, and John). They include three full-page miniatures, all illustrating episodes from the miracles and ministry of Christ that are rarely found in early medieval art.

The story of the miracle of the stater is briefly outlined in the Gospel of Saint Matthew (17:26): at Capharnaum, Jesus instructed Saint Peter to go to the sea and cast his hook so that he might find in the mouth of the first fish he caught a coin (or stater) with which to pay a tax. The Anglo-Saxon illuminator has presented the story in two scenes that imply three moments in the story (leaf 2). The scene above seems to show both Jesus instructing Peter—conveyed in Jesus' gesture—and Peter returning with the stater, while the scene below shows Peter catching the fish. Thus the illuminator cleverly plays on our expectation that the scenes should be read from top to bottom and instead presents a narrative that moves from the upper scene to the lower scene and back up.

The visual interest of the miniature is enhanced by the illuminator's lively drawing style, one favored in late Anglo-Saxon manuscript painting. This technique has its distant roots in the impressionism of ancient Roman painting, but Anglo-Saxon artists exploited its expressive potential more than their ancient predecessors had. The agitated drawing is especially effective in the depiction of the surface of the water and the wriggling fish on Peter's hook. ECT

3 Sacramentary
 Fleury, first quarter of the
 eleventh century

 10 leaves, 23.2 x 17.8 cm
 (9⅛ x 7¹/₁₆ in.)
 Ms. Ludwig V 1; 83.MF.76

 Plate: Attributed to Nivardus of Milan,
 Decorated Initial *D* with Clambering
 Figures, fol. 9

A sacramentary is a book containing the prayers recited by the celebrating priest at mass—the Christian rite in which bread and wine are consecrated and shared. Serving as a part of the adornment of the altar during mass, sacramentaries were often illuminated in the early Middle Ages, especially if they were made for presentation to powerful political or ecclesiastical officials.

This sacramentary, only a fragment of which is preserved, may have been made for Robert the Pious, King of France (r. 996–1031), perhaps at the behest of the Bishop of Beauvais, who crowned Robert in 1017. The writing and illumination have been attributed to Nivardus, an Italian artist who worked at the Benedictine monastery of Saint-Benoît-sur-Loire at Fleury in France. Nivardus's gold and silver initials were inspired by those of illuminators active at the monasteries of Saint Gall and Reichenau (see no. 1), but his initials are distinct in the abundance of the knot work. This exuberance of decoration sometimes obscures the shapes of the letters.

The initial *D* that introduces the prayers for Easter (fol. 9) is framed by a pair of columns surmounted by vines that complement the form of the initial. The decoration of the page is further enhanced by the inclusion of a pair of clambering figures, their poses and the colors of their clothing contributing to the lively and masterfully harmonized design of the page as a whole. ECT

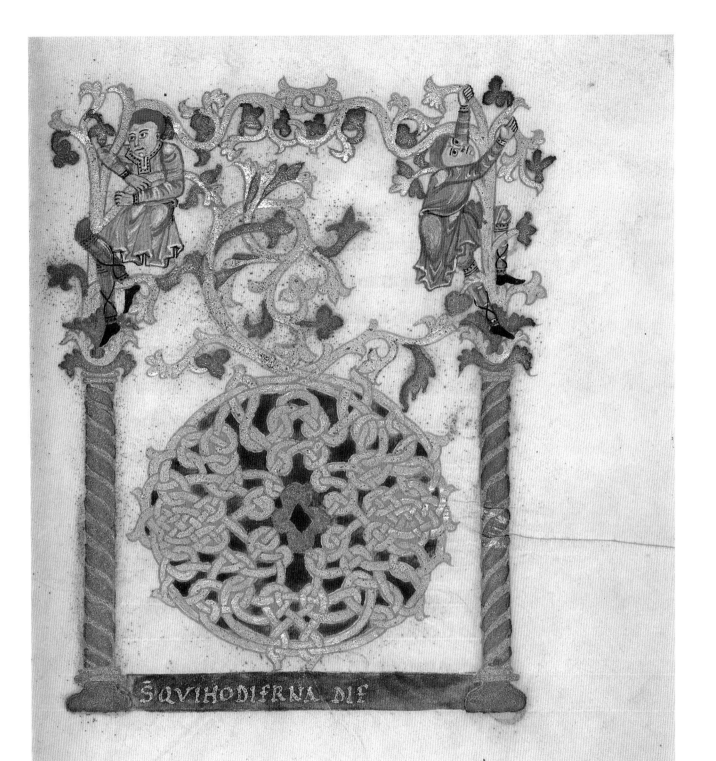

ŚQVIHODIERNA DIE

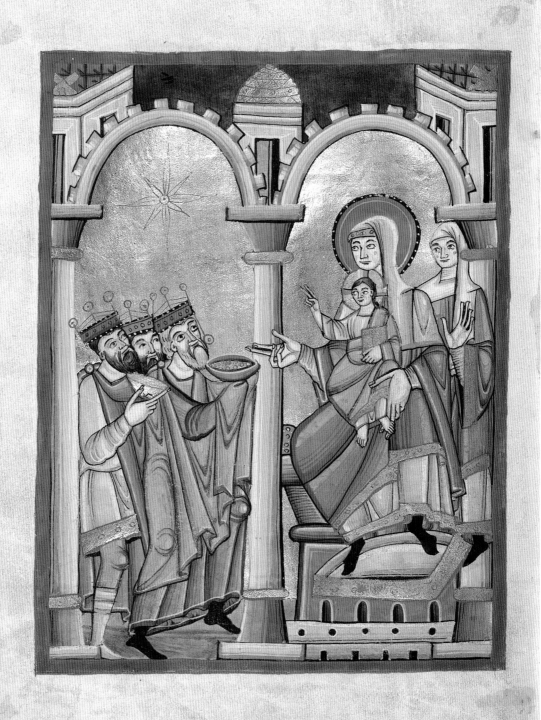

4　Benedictional

Regensburg, circa 1030–1040

117 leaves, 23.2 x 16 cm
(9⅛ x 6⁵⁄₁₆ in.)
Ms. Ludwig VII 1; 83.MI.90

Plate: *The Adoration of the Magi,*
fol. 25v

Regensburg, the capital of Bavaria in the Middle Ages, was one of the most important political, religious, and cultural centers in all of Europe. The luxury manuscripts produced under the patronage of the Ottonian emperor Henry II (r. 1014–1024) attest to Regensburg's prosperity at this time, and for the rest of the century the city would remain the focal point of a flourishing culture that extended throughout the region.

This benedictional, a book containing the blessings recited by the bishop at mass, was made for Engilmar, who is depicted celebrating mass on the original opening page of the manuscript. Engilmar's career reflects the wide-ranging ties made possible by the network of Benedictine monasticism. First a monk in the monastery at Niederaltaich (Bavaria) and later the Bishop of Parenzo (modern Poreč in northwestern Slovenia across the gulf from Venice), Engilmar was an honored guest at Saint Emmeram, Regensburg's chief monastery. Stylistic comparisons to other manuscripts indicate that the bishop turned most likely to Saint Emmeram for the production of his benedictional, sometime between 1030 and 1040.

The Adoration of the Magi is one of seven full-page narrative scenes from the Life of Christ in the book and introduces the feast of Epiphany on January 6. The subject was one of the most popular in medieval art, and the benedictional's picture relies on earlier Ottonian art from Reichenau for its composition. The figures here loom large in relationship to the framing architecture, and they are highlighted by the gleaming gold background that reinforces the miraculous aspect of the event. The monumentality of the enthroned Virgin Mary is particularly striking as she and Jesus respond dramatically to the adoring kings. Such demonstrative hand movements are a quintessential trait of Ottonian art, in which the language of gesture found some of its most lyrical visual expression.　　　　　　　　　　　　　　　　　　　　　　　　　ASC

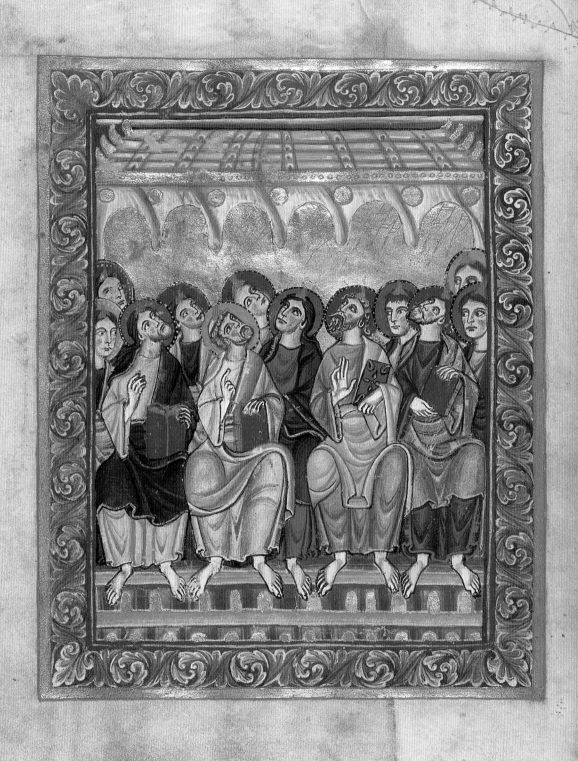

Pomia scla sclorū · amen ·

Dñs uobiscū · et cū spū tuo ·

Sursū corda · Habem ad dñm ·

Grās agam dño dō nrō ·

Dignū et iustum est ·

5 Sacramentary
 Mainz or Fulda, second quarter
 of the eleventh century

 179 leaves, 26.6 x 19.1 cm
 (10½ x 7⁷⁄₁₆ in.)
 Ms. Ludwig V 2; 83.MF.77

 Plates: *Pentecost* and Incipit Page,
 fols. 20v–21

 See pages 18–19

Archbishop Bardo of Mainz (in modern Germany) probably gave this richly
illuminated sacramentary, together with relics of Saint Alban (d. 406), to the Cathedral
of Saint Alban at Namur (in modern Belgium) at the time of its foundation in 1046.
The book, whose covers are embellished with metalwork and enamels, would have been
kept in the cathedral's treasury and placed on the altar for use at mass only on important
feast days.

The most remarkable artistic feature of this sacramentary is the series of six
full-page miniatures of key events in New Testament history that precedes the main
text. Such prefatory cycles are rare in early medieval liturgical manuscripts. The final
miniature of the series shows the descent of the Holy Spirit on the apostles at Pentecost
(fol. 20v). The miniature is a literal representation of the event as it is described in the
Bible (Acts 2:1–4). The apostles are sitting in a house as "parted tongues of fire alight
on each one of them." Although the inclusion of the roof sets the scene in a house, the
gold background imparts an otherworldly character, emphasizing that the apostles
"were all filled with the Holy Spirit."

The Pentecost miniature harmonizes with the text page opposite (fol. 21) through
the shared colors of the large frames decorated with foliate motifs. The text, the
opening of one of the prayers of the mass, is written in gold on a purple and green
background. This treatment deliberately imitates the appearance of the most
sumptuous manuscripts of the Roman imperial period, in which the texts were
written in precious metals on purple-dyed parchment. ECT

6 Gospel Book
Helmarshausen, circa 1120–1140

168 leaves, 22.8 x 16.4 cm
(9 x 6½ in.)
Ms. Ludwig II 3; 83.MB.67

Plates: *Saint Matthew* and Incipit
Page, fols. 9v–10

See pages 22–23

The Gospels, the accounts of Christ's life attributed to Saints Matthew, Mark, Luke, and John, lie at the center of Christian teaching. From the seventh to the twelfth century the most important and beautiful illuminated manuscripts produced in Western Europe were Gospel books. This twelfth-century example, one of the finest manuscripts in the Getty Museum's collection, was produced at the Benedictine Abbey at Helmarshausen in northern Germany.

Each Gospel is prefaced by a portrait of the author, a pictorial tradition that originated in antiquity. Here we see Saint Matthew writing the opening lines of the text: *Liber generationis jesu christi filii David filii habrah[am]* (The book of the generations of Jesus Christ son of David son of Abraham). The inscription above Matthew's head reads "The beginning of the Holy Gospel according to Matthew." The writer holds a quill pen and a knife to sharpen it. Two ink-filled horns are set into the lectern.

The large areas of rich color and the pattern of folds of the bulky robe are particularly characteristic of Romanesque art. The folds are simplified into geometric shapes and frequently "nested," that is, set neatly within one another. Despite this stylization, Matthew is a robust, full-bodied figure. As is usually the case with illuminated manuscripts from the Middle Ages, we do not know the artist who painted these pages. The eminent metalsmith Roger of Helmarshausen, who was active in Lower Saxony at the beginning of the twelfth century, designed figures in a strikingly similar manner.

The incipit, or opening lines of a text, often received artistic attention equal to that given the miniatures. This incipit page shows a large letter *L* constructed of interlaced and spiraling vines of gold leaf, a flight of artistic fancy. The other letters of *Liber* form part of the design. An *I* in silver is slotted among the golden vines. The final three letters appear in gold to the right. The remaining words are written in letters of alternating gold leaf and silver against a densely patterned background of burgundy. This background imitates the expensive silks from Byzantium that Western Europeans admired and regarded as precious objects. Byzantine silks were frequently used to cover such highly valued manuscripts as this Gospel book. TK

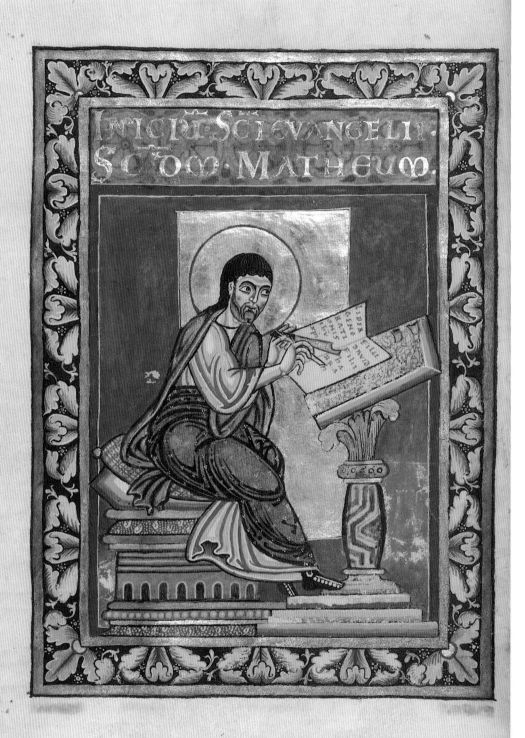

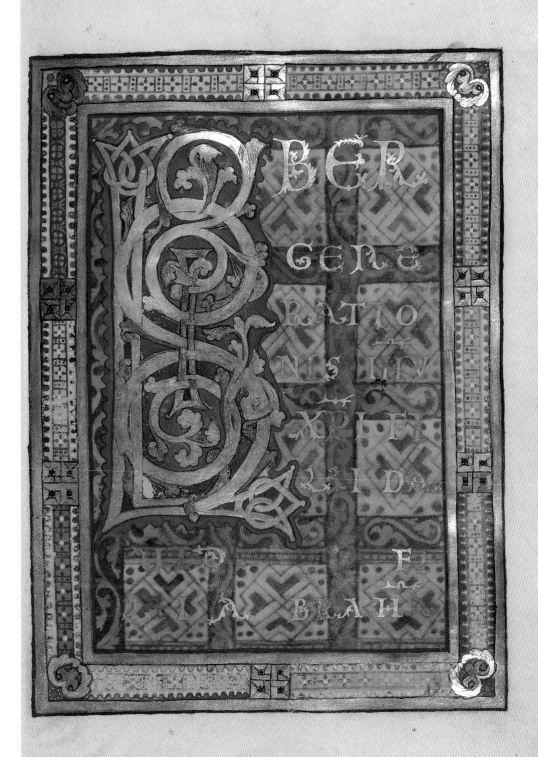

LIBER GENERATIONIS IHV XPI FILII DAVID FILII ABRAHA

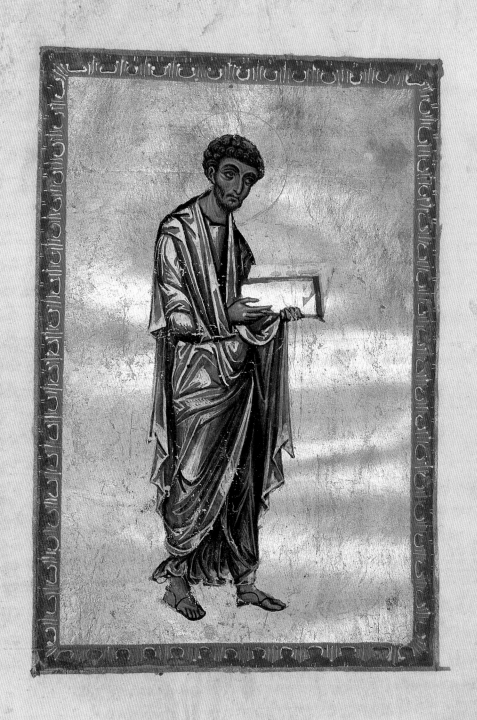

7 New Testament
Constantinople, 1133

279 leaves, 22 x 18 cm
(8¹¹/₁₆ x 7⅛ in.)
Ms. Ludwig II 4; 83.MB.68

Plate: *Saint Luke,* fol. 69v

The Roman emperor Constantine (the Great) was responsible for two of the most profound acts in European history. As the first emperor to convert to Christianity, Constantine provided official impetus toward the wide-scale spread of the relatively new religion, and when he chose to move the imperial capital away from Rome in 330, he decisively shifted the political and cultural focus of the empire. As the heart of the emerging Byzantine realm, Constantinople (modern Istanbul, located on the Bosporus between Europe and Asia Minor) was considered the "new Rome," and its inhabitants always regarded themselves the true heirs of the classical legacy.

Byzantine art reflects this dual Roman and Christian heritage, as the portrait of Luke in this manuscript demonstrates. The antique garb and careful modeling of the face ultimately stem from classical art, while the placement of the figure against a shimmering gold background suggestive of heaven is consonant with the medieval Byzantine aesthetic. Part of a long tradition of evangelist portraits, the images of Luke and the other three Gospel authors are representative of the twelfth-century Comnenian style (named after the ruling dynastic family). Although based on earlier models from the ninth and tenth centuries, the vigorous drapery and somewhat attenuated poses reveal that Byzantine art was also moving toward a more abstract and dynamic phase.

According to an inscription near the end of the manuscript, this New Testament was finished in the year 1133 by Theoktistos, almost surely in Constantinople, where this scribe wrote another book for a prominent monastery. (However, he is not specifically identified as a monk.) The Getty manuscript is thus one of the few deluxe Byzantine books that can be accurately dated and localized. It serves as a benchmark of the artistic continuity and stylistic innovations in twelfth-century Byzantine art. ASC

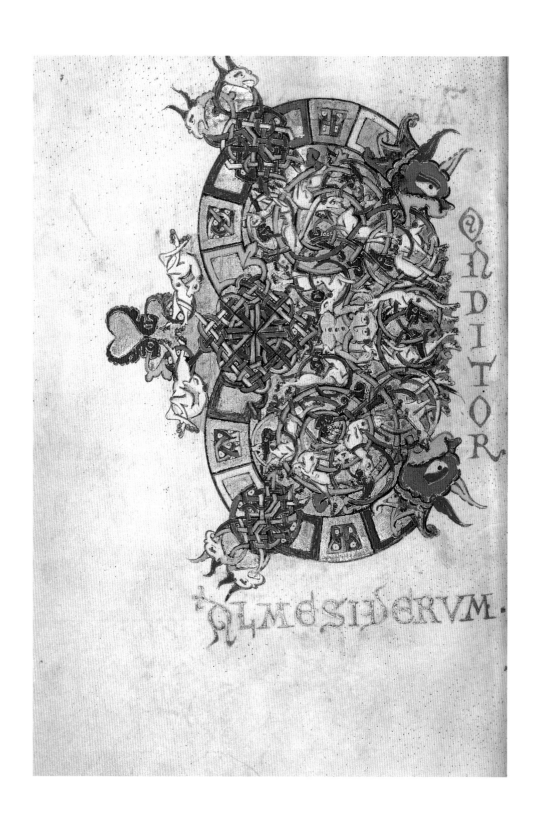

N DITOR

ALME SIDERVM.

8 Breviary
 Montecassino, 1153

 428 leaves, 19.1 x 13.2 cm
 (7⁹⁄₁₆ x 5³⁄₁₆ in.)
 Ms. Ludwig IX 1; 83.ML.97

 Plate: Decorated Initial *C*, fol. 259v

This manuscript was made at the Monastery of Montecassino in southern Italy, the cradle of Benedictine monasticism and an important center for the production of books. Among the manuscript's texts is a prayer that names "the Lord's servant Sigenulfus" as the scribe. Undoubtedly a monk of the abbey, Sigenulfus may have been responsible for both the writing and the illumination of this splendid book.

Benedictine monks and nuns lived in organized communities apart from the secular world. Much of their waking day was occupied with the celebration of the eight services that make up the divine office (the prayer liturgy of the Catholic Church, consisting principally of the recitation of psalms and the reading of lessons). Medieval manuscripts containing the texts of the office, called breviaries, were sometimes large volumes intended for communal use, but more often they were small books, like this one, designed to be used by an individual.

The Museum's breviary from Montecassino is extremely richly illuminated, with twenty-eight large decorated initials and over three hundred small initials. This letter *C* formed of panels, interlace, and spiraling tendrils painted in gold and brilliant colors introduces the hymn for the first Sunday in Advent: *Conditor alme siderum . . .* (Creator of the heavens . . .). A pair of bold, blue animal heads form the ends of the letter's curves, and a curious human figure occupies the center of the design. Fantastic doglike creatures twist through the tendrils biting at the vines, each other, and their own bodies. The remainder of the text is in fancy gold capitals. The bright yellow and blue and the biting dogs of the initial are especially characteristic of Montecassino manuscript illumination of the period. ECT

9 Gratian, *Decretum*
 Sens or Paris, circa 1170–1180

 239 leaves, 44.2 x 29 cm
 (17 7/16 x 11 7/16 in.)
 Ms. Ludwig XIV 2; 83.MQ.163

 Plates: Initial *I* with *Scenes of Secular
 and Ecclesiastical Justice,* fol. 1
 Initial *Q* with *An Abbot Receiving a
 Child,* fol. 63

As a teacher in Bologna, the monk Gratian organized the study of Church law with his compilation of the *Decretals,* an unprecedented collection of nearly four thousand texts drawn from Early Christian writings, papal pronouncements, and council decrees. Completed sometime between 1139 and 1159 (the year of Gratian's death), the *Decretals* quickly became the standard textbook throughout Europe in the field of canon law. The use of such standardized texts became increasingly important with the formation and rise of universities at the end of the twelfth and throughout the thirteenth centuries, particularly in Paris, Bologna, and Oxford.

In the initial *I* that opens this manuscript, medallions show the king and bishop as representatives of secular and spiritual law, demonstrating the importance of the separation of powers. In the initial *Q,* simony is illustrated as an abbot receives a child into the monastery along with payment from the father. Simony, the improper traffic in holy things, was a significant problem confronted by Church law. Named after Simon Magus, who was reprimanded by Saint Peter for wanting to acquire the power of the Holy Spirit (Acts 8:9–24), it most commonly referred to monetary transactions involved in appointments to Church offices. Abundant medieval decrees indicate that simony was a recurring concern.

With their combination of imaginative hybrid creatures and coiling tendrils, both initials are typical of northern French Romanesque painting strongly influenced by English art. This is evident too in the abbot's robe, where the drapery is rendered in broad patches, revealing the substance of the body beneath the cloth. The decoration of this manuscript connects it to a group of books produced for Thomas Becket, Archbishop of Canterbury, and his secretary Herbert of Bosham while they were in exile in France between 1164 and 1170. It is not clear, however, whether the Getty manuscript and the other books were illuminated in Sens, the site of Becket's exile, or nearby Paris. ASC

PRIMA

...parte agitur de iusticia natura-
li et positiua. tam instituta quam incon-
stituta. que cui apponatur. de iure
ciuili et ecclesiastico. quod cum profematur.
de auctoritate et canonicarum scrip-
turarum. gestorum. tam generali-
um quam prouincialium. de noticia apocri-
forum librorum. decretalium quoque
epistolarum. nec non aliarum scriptu-
rarum que autentice uocantur. Agi-
tur et in ea de diuisis ordinibus. eccla-
sia est. quisint. unde originem et nomen
acceperint. de auctoritate quoque. ista-
rum ecclesiarum. que inter cetera primum
et secundum et tercium locum obtine-
at. qualiter in ecclesia per singulos gradus
quisque promoueri debeat. De conui-
satione et professione ordinandorum.
de habitu et officio ordinandorum.
Quemadmodum. quo tempore. episco-
rum et presbyterorum et ceterorum exami-
natio fieri debeat. Quid ad episcopum. quod
ad inungendos inferiorum. specialiter
pertineat. qui ex quibus ordinibus et quo-
gradum ascendere possint. qui post
lapsum ualeant reparari et non. Agitur etiam
in ea de episcopis et archiepiscopis et ceteris a quibus sint eli-
gendi. et ordinandi. usque ad quem episcopi
electionem differri liceat. quo modo episcopi sacri ordinari
sint distribuendi. an semel ordinatus in eodem
ordine iterum sit ordinandus. de differentia episcoporum
et corepiscoporum. de his qui ab episcopis suis promoueri pre-
cipiuntur. an sint cogendi et non. an et inuitus teneri
debeat aliquis. in eo loco in quo ordinatus est.
Quo tempore episcopi consecrentur post electionem eorum.
usque ad quem terminum ipsorum consecratio differri
ualeat. Quo modo presbyteri diaconi et ceteri sint ordinandi.
quibus temporibus. et ieiunia sint celebranda. quibus
temporibus. iustitiis. qua etate per singulos gradus
promoueri debeant. a quibus et et romane sedis episcopi ex
quibus sint eligendi et ordinandi. de cuius electio-
ne et deliberare predecessorem oportet. cui reseruen-
tur eorum electio. In quibus locis patriarche.
primates. archiepiscopi. episcopi. corepiscopi et reliqui sacerdotes
sint ordinandi. Sequitur in ea breuis scrip-
tulario superiorum. que electum ad quelibet spo-
situum ecclesie uber esse sine crimine. quod si
ante tempus sue ordinationis et post. aliqui mor-
tale admisisse nuncietur. suscepti gradus officio
ibidem priuandus docetur. Agitur et in ea de
retractione lapsorum. de munditia clericorum. de
indisciplinato accessu et reprehensibili cohabitatione
ac suspiciosa familiaritate clericorum et mulierum.
de reparatione lapsorum post penitentiam. qui a
suis munduis est. prohibetur et alienis consequi pecca-
tis. ne aliorum uicia palpet. ne luporum laudib...

...huic filium obtulit
cum duxisset eum ce-
nobio. extractus ab
altari ista tribus.
decem libras soluit
ut filius susciperetur. ipso cum bene-
ficio erant ignora-
re. Creuit puer et
per incrementa tem-
porum officiorum. ad uirilem etatem et sacerdotii
gradum peruenit. Exinde substigantibus. multis
in eum eligunt. Inueniente obsequio et patris pec-
unie. data quoque pecunia eiusdam ex consiliariis episcopi
episcopi. consecratur iste in antistitem. nescius patris
obsequii et oblate pecunie. Procedente uero tempore
nonnullos pro peccuniam ordinauit. quibusdam
ordinationis benedictionem sacerdotalem dedit. Tan-
dem apud metropolitanum suum accusatus et con-
uictus. sententiam in se dampnationis accepit.
Hic primum queritur. an sit peccatum emere spi-
ritualia. Secundo. an in ingressu ecclesie sit ex-
igenda pecunia. Si exacta fuerit. an sit persolue-
da. Tertio. an ingressum et prebendas ecclesie eme-
re sit symoniacum. Quarto. an iste sit reus
criminis quod eo ignorante pater omisit. Qui-
to. an liceat ei esse in ecclesia et fungi ea ordinatio-
ne quam patria pecunia est assecutus. Sex-
to. an illi qui ab eo iam symoniaco ignorante or-
dinati sunt. sint abiciendi an non. Septimo.
si renuncians siue heresi. sit recipiendus in episcopali
dignitate an non. Quod autem spiritualia
emere peccatum sit. probatur multorum aucto-
ritatibus. Ait enim leo papa. Symoniaci etiam non
iusticia si non gratis datur. istam quem uoce queritur.
accipitur. non est gratia. Symoniaci autem et non
gratis accipiunt. gratiam quam que maxime in ec-
clesiasticis ordinibus. operatur. non accipiunt. Si
autem non accipiunt. non habent. Si autem non habent
negant gratiam. negant non gratis cuique dare possunt.
Quid...

10 Canon Tables
from the Zeytᶜun Gospels
Hromklay, 1256

8 leaves, 26.5 x 19 cm
(10⁷/₁₆ x 7½ in.)
Ms. 59; 94.MB.71

Plates: Tᶜoros Roslin, Canons 2–5,
fols. 3v–4

See pages 30–31

Tᶜoros Roslin was the most accomplished master of Armenian manuscript illumination. His work is remarkable both for its consummate artistry and for its incorporation of motifs learned from Western European and Byzantine art. Active in the second half of the thirteenth century, he wrote and illuminated manuscripts for the Cilician royal family and for Catholicos Kostandin I (1221–1267), the highest official of the Armenian Church.

Christianity became the official religion of the Arsacid kingdom of Greater Armenia in the early fourth century. The belief of the Armenian Catholic Church is distinct from the Roman Catholic and Orthodox traditions, although the doctrines of the Armenian Church are similar to those of the Eastern Orthodox faiths. The Armenian language was not a written language until after the adoption of Christianity; the alphabet was most probably created in order to preserve and disseminate scripture, and Bibles and Gospel books number among the most sumptuous of manuscripts in Armenian.

Compiled by Eusebius of Caesarea, canon tables consist of columns of numbers that present a concordance of passages relating the same events in the four Gospels. Canon table pages attracted decoration in manuscript Bibles and Gospel books throughout the Middle Ages, the columns of numbers naturally inviting an architectural treatment. On these pages, Roslin has placed the text within a grand and brilliantly colored architecture with column capitals formed of pairs of birds. The whole shimmers with gold, and the vase at the top of the left page is carefully modeled in silver and gold. The grandeur of the architecture and the symmetry of the trees contrast with the naturalism of the hens that dip their heads to peck at a vine and drink from a fountain. ECT

11 Dyson Perrins Apocalypse
England (probably London),
circa 1255–1260

41 leaves, 31.9 x 22.5 cm
(12⁹/₁₆ x 8⅞ in.)
Ms. Ludwig III 1; 83.MC.72

Plates: *Unclean Spirits Issuing from
the Mouths of the Dragon, the Beast,
and the False Prophet* and *The Angel
Pouring Out from the Seventh Vessel,*
fols. 34v–35

See pages 34–35

Thirteenth-century England saw the creation of a large number of illuminated manuscripts of the Apocalypse (Book of Revelation), Saint John the Divine's vision of the events leading to the Second Coming of Christ at the end of time. The Apocalypse had a particular resonance for Western Europeans in the mid-thirteenth century; recent cataclysmic events, including the invasion of Russia by the Tatars (1237–1240) and the fall of Jerusalem to the Moslems (1244), suggested that the end of time was near. The enigmatic text of the Apocalypse invited interpretation, and this manuscript includes the commentary most commonly found in English Apocalypses, that of Berengaudus (a monk about whom nothing is known except that he wrote this commentary).

Every page of the Dyson Perrins Apocalypse, named for a previous owner of the manuscript, includes a half-page miniature, a brief passage from the Apocalypse (in black ink), and a portion of Berengaudus's commentary (in red ink). The miniatures are in the tinted drawing technique, which reached a level of great sophistication in thirteenth-century England. They vividly illustrate the biblical text in compositions of great clarity. Saint John is often shown experiencing his vision, either from within the scene or peering from the margin through an opening in the miniature's frame.

One miniature (fol. 35) depicts an angel pouring from a vessel, which unleashes "lightnings, voices, thunders, and a great earthquake" (Apocalypse 16:17–18). An oversized Saint John seems to turn back just in time to see the destruction brought about by the earthquake. The "great voice out of the temple from the throne" is represented as a half-length figure of Christ within a mandorla emerging from a building surrounded by clouds. The heavenly temple appears to be suspended from a small peg in the upper margin of the page, a visual delight entirely unaccounted for in the text. ECT

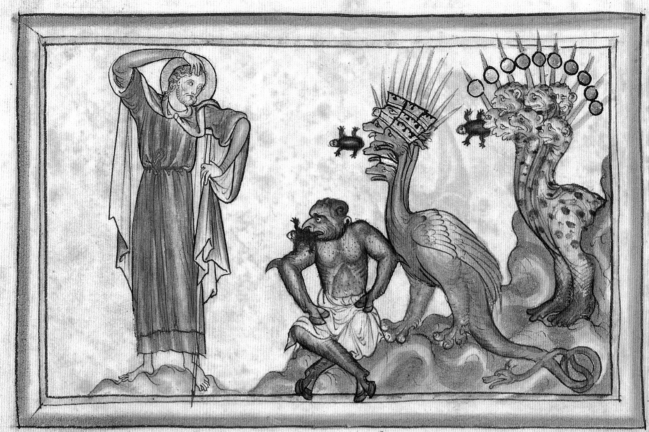

Et uidit de ore draconis ⁊ de
ore bestie ⁊ de ore pseudo p-
phete spiritus tres immundos
i modum ranar̄. Sunt eni̅
sp̄s demonior̄ fatientes signa. Et pde̅t
ad reges terre totius congregare illos ⁊
prelium ad diem magnu̅ dei omni-
potentis. Ecce uenio sicut fur. Beatus qui
uigilat ⁊ qui custodit uestimenta sua.
ne nudus ambulet ⁊ uideant turpitudi̅e̅
eius. Et congregauit illos in locum qui
uocatur ebraice ermagedon

Sunt au̅ sp̄s demonior̄ fatientes signa
uocatione g̅entium descripta quasi ad
ad fidem xp̄i ueniu̅t mentione̅ fatit antixp̄i
qui ppe finem mundi uenturus ⁊. Sp̄s u̅ tres
immundi discipulos desig̅na̅t antixp̄i qui p

uniu̅sum orbem predicaturi sunt. Q̅ h̅moīs
homines sunt futuri spē immu̅di ⁊ spē demo-
niorz uocant. q̅ demones in ipsis h̅itabunt ⁊
p ora eor̄ loquentur. Qui de ore antixp̄i ⁊ de
ore pseudo xp̄e ē exisse uisi sunt. q̅ p eos doc-
trinam filii diaboli efficient. Qui ⁊ de ore dra-
conis exisse uisi sunt. q̅ p eos antixp̄i diabolus
loquet̅. Ranis nichominus que sunt reptilia immu̅-
da ⁊ i luto uiuentia recte assimula̅t. q̅ sic
rane i sordidis aq̅is ymorant̅ ita ⁊ discipuli an-
tixp̄i eos facile decipient qui diuitiis uncti ⁊ sor-
dibus no timuerint sordidari. Ranu ⁊ raucu uox
ranea ⁊ turpis. impurissima̅ eor̄ predicationu̅
blasphemiis plena designat. Et pdent ad
reges tr̄e ⁊c. P reges terre. no solum reges s̅
⁊ populi designant̅. Dies au̅ domini sic fur in
nocte ueniet. cum ꝑ dixerint pax ⁊ securitas
t̅c repentinus eis superueniet interitus.

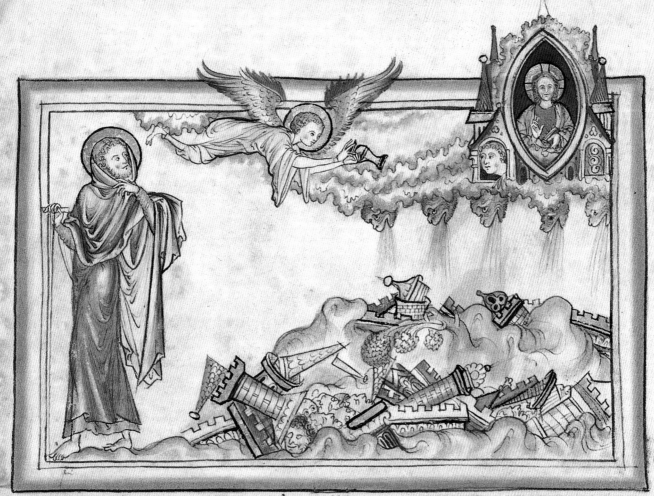

Et septimus angelus effudit
phialam suam in aerem ⁊
exiuit uox magna de templo
a throno dicens factum est.
Et fca sunt fulgura ⁊ uoces ⁊ tonitrua ⁊
terre motus factus est magnus quar nuq̄
fuit ex quo homines fuerunt sup tram ta
lis terre motus sic magnus. Et fca est ciui
tas magna in tres ptes ⁊ ciuitates gentiu
ceciderunt. Et babilon magna uenit i me
moriam ante dm̄ dare ei calicem uini
indignationis ire eī. Et omnis insula fu
git ⁊ montes nō sunt inuenti. Et grando
magna sicut talentum descendit de ce
lo in homines ⁊ blasphemauerunt dm̄
homines ꝓꝑ plagam grandinis q̄m
magna fca est uehemenſ.

Per septimū istum anḡlm predicatores sc̄i
qui temporibz antixpi fuerūt designat̄
Angelis ꝙ phialam sua i aerem effudit ꝙ pre
dicatores sc̄i uiuis ⁊ impiis hominibz qd̄ pena
pena sunt dampnandi denūciabit. Et exiuit
uox magna ⁊ c̄. Vox magna uox est predica
tor̄ sc̄ōꝝ ꝑ templum ecc̄a intelligit. A ꝑple
ꝙ uox exiuit ꝙ ab ecc̄a uox sc̄e predicationis
predit. Que ⁊ a throno exisse dr̄ ꝙ ecc̄a dr̄ th
ronus e dr̄ ⁊ in illa sedens requiescat. Qud̄ aū
hec uox dicat subdendo manifestat. fc̄m e
⁊ c̄ tinis mundi instat in q̄ omnia que p̄dica
sunt a dn̄o ⁊ a sc̄is complebunt. ꝑ fulgura si
miracula que ꝑ sc̄os suos factur̄ is ⁊ c̄ desig
nant. Legimus nānꝙ i superioribz helyam
⁊ enoch plurima signa ee facturos. ꝑ uoces
sī predicatio sc̄ōꝝ. ꝑ tonitrua sū terroꝝ
inis exprimuntur.

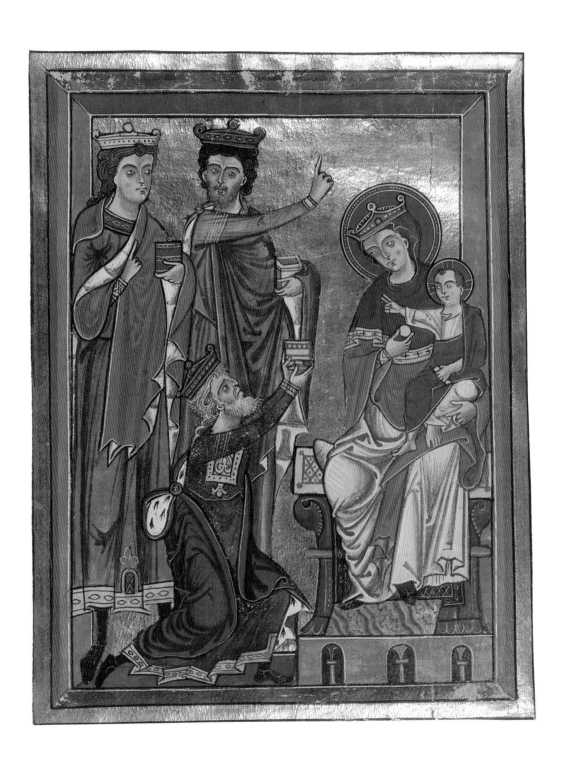

12 Two Miniatures from a Psalter
 Würzburg, circa 1240

 17.7 x 13.6 cm (7 x 5⁵⁄₁₆ in.)
 Ms. 4; 84.ML.84

 Plate: *The Adoration of the Magi,* leaf 2

Situated at the heart of monastic religious life, the recitation of the psalms played a central role in Christian devotions throughout the Middle Ages. By the thirteenth century, the psalms became the focus of private devotion. A psalter consists of all 150 psalms along with a calendar of Church feasts and other texts. It was the first important prayer book for lay worshipers and a vehicle for lavish decoration.

This *Adoration of the Magi* is one of two large miniatures in the Getty collection from a picture cycle removed from a thirteenth-century psalter made at Würzburg in Bavaria. Eighteen others in this cycle are known, including sixteen in the British Library, and the suite of miniatures was undoubtedly larger still. (The rest of the manuscript—including its text—is lost.) The miniatures tell the story of the Life of Christ, beginning with the Annunciation to the Virgin Mary, through Christ's infancy, trials, death, and Resurrection. This dramatic sequence of New Testament miniatures would have preceded the psalms themselves and focused the worshiper's attention on the heart of Christianity—the example of Christ himself.

The Würzburg school of manuscript illumination flourished in the middle of the thirteenth century. Our knowledge of it derives from this fragmentary psalter and half a dozen other books that survive, most of them also psalters (see no. 13). Whereas the finest painted books throughout the Middle Ages feature expensive pigments and precious metals, the backgrounds of highly burnished gold leaf are especially characteristic of German, French, and Flemish manuscripts of the thirteenth century. Lacking any indications of setting, the luminous, undifferentiated background focuses the viewer's attention on the story of the three kings from the east, who follow a star in search of the baby Jesus, "he who is born to be king of the Jews." The king at the center, with arm raised, points to the unseen celestial body that led him and his companions to Bethlehem. The artist depicts the Christ Child not in the humble manger where he was born but sitting prominently in the lap of his mother, who is seated on a regal throne. TK

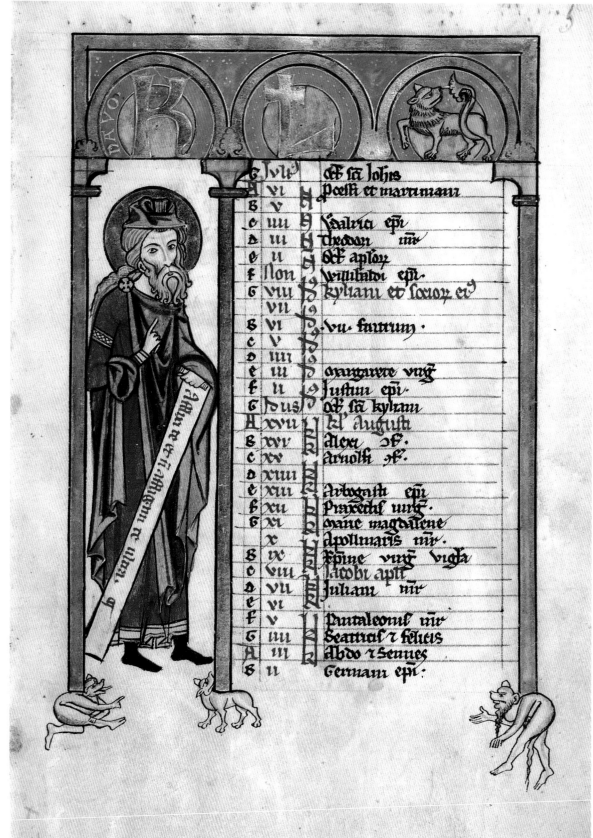

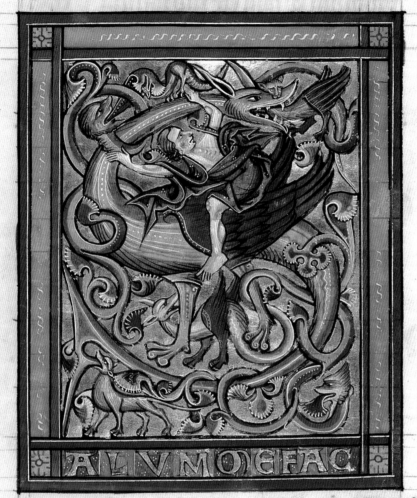

A L V M O S F A C

Deus qñ intrauerunt aque ulqʒ ad a
nimam meam I n firmis sum limo

13 Psalter

Würzburg, circa 1240–1250

192 leaves, 22.6 x 15.7 cm
(8¹⁵⁄₁₆ x 6³⁄₁₆ in.)
Ms. Ludwig VIII 2; 83.MK.93

Plates: Calendar Page for July, fol. 4
Decorated Initial *S* with *Griffin and Rider,* fol. 76

See pages 38–39

During the course of the thirteenth century the illuminated psalter, especially in Germany, Flanders, France, and England, became the most profusely decorated of books. This psalter was made in Würzburg toward the middle of the thirteenth century by artists closely related to the painter of the preceding miniature. They must have known each other and on occasion worked together. This book was decorated from front to back with a range of both religious subjects and playful decoration.

The book opens with a calendar listing the saints' days and other holidays celebrated in the course of the Church year. The calendar is illustrated with images of lesser prophets of the Old Testament, Nahum appearing for July (fol. 4). He holds a scroll from his writings: "Though I have afflicted thee, I will afflict thee no more." (Nahum 1:12).

In order to facilitate their recitation during the course of the week's devotions, the psalms are divided into a total of ten sections. Full-page miniatures including both Old and New Testament subjects appear before Psalm 1, and others precede Psalm 51 and Psalm 101. The illuminator introduced the seven remaining sections with large decorated and inhabited initials, the latter being particularly inventive. In the example shown here the initial *S* has been transformed into a griffin ridden by a loosely robed youth and entwined with foliage and other beasts. The text *Salvum me fac* begins Psalm 68 (Save me, oh Lord, for the waters threaten my life . . .).

Often the names of illuminators and patrons of even the finest medieval manuscripts are not known. Artists in particular rarely signed their works. We know this book was made in Würzburg in part because of the liturgical indications in the text and in part because of its close relationship to the illumination of a Bible made in Würzburg in 1246. One of the painters of the Bible signed one of its miniatures: *Hainricus pictor* (Henry the Painter). The illuminators of the Getty psalter and of the miniatures in no. 12 undoubtedly knew Henry, but their names remain lost to us.

TK

14 Wenceslaus Psalter
Paris, circa 1250–1260

203 leaves, 19.2 x 13.4 cm
(7 %₁₆ x 5¼ in.)
Ms. Ludwig VIII 4; 83.MK.95

Plate: Initial *B* with *David Playing
Before King Saul and David Slaying
Goliath,* fol. 28v

See page 42

The mythic place that Paris occupies in the modern imagination as a center of beauty and the visual arts has deep historical roots. They penetrate to the twelfth century when the Gothic style emerged in architecture and art of the Île-de-France, the region along the River Seine with Paris at its center. Monumental stained glass enriched the walls of its cathedral, churches, and chapels. In the thirteenth century a lively industry of book production flourished there as well. The city quickly became famous throughout Europe as a center of manuscript painting. Indeed, in the early fourteenth century in distant Florence, the poet Dante (1265–1321) mentions in *The Divine Comedy* "the art which in Paris is called illuminating."

This psalter offers evidence of the international appeal of Parisian Gothic manuscript illumination. It contains over 160 narrative scenes from the Old and New Testaments and countless initials painted with generous quantities of gold leaf and costly pigments. Within a generation of its creation, a Bohemian nobleman (in the modern-day Czech Republic) acquired it. Some scholars believe that he was no less than King Wenceslaus III of Bohemia (r. 1305–1306).

The most important decoration of a psalter is the *Beatus* initial page, containing the illustration to the first psalm: *Beatus vir* . . . (Blessed is the man . . .). The initial is formed by vines that culminate in animal heads and roundels filled with stories of David. In the *B*'s upper lobe the young David plays his harp before Saul; in the lower one the boy slays Goliath. As if with jewels, the frame of the page is encrusted with additional scenes from David's life. The crowded design of this initial is not unlike that of stained-glass windows, constructed of a pattern of lozenges and roundels, each with an individual scene, usually narrated with only a few figures. Whereas the luminosity of stained glass derives from external light transmitted through the colored glass, in Gothic books the highly burnished and reflective backgrounds of gold leaf next to saturated colors strive for a similarly brilliant effect. TK

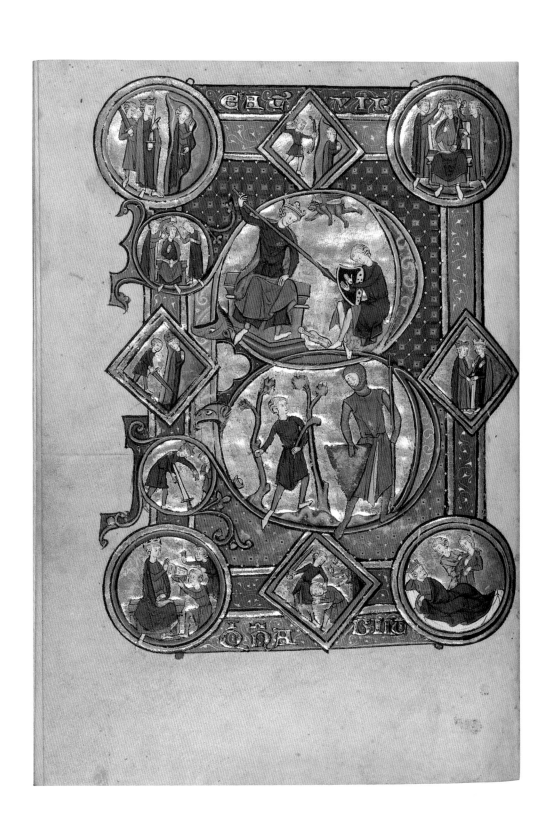

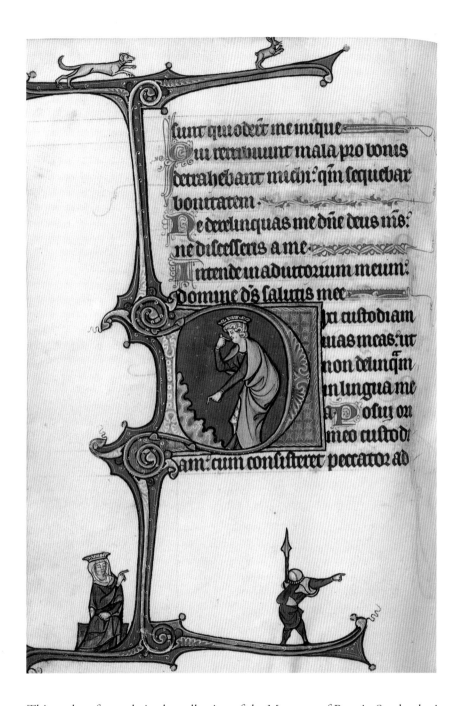

15 Bute Psalter
Northeastern France,
circa 1270–1280

346 leaves, 16.9 x 11.9 cm
(6 ¹¹⁄₁₆ x 4 ¹¹⁄₁₆ in.)
Ms. 46; 92.MK.92

Plate: Bute Master, Initial *D* with
King David Pointing to His Mouth,
fol. 52v

This psalter, formerly in the collection of the Marquess of Bute in Scotland, gives
the name "Bute Master" to its anonymous artist. The Bute Master worked in the
prosperous cities of the Franco-Flemish border region, contributing to the illumination
of a dozen sacred and secular manuscripts. He or she sometimes collaborated with other
illuminators, a common practice in the thirteenth century, but was entirely responsible
for this manuscript's 190 historiated initials.

An intimate connection between text and image is evident in some of this book's
initials. One of the largest introduces Psalm 38 (fol. 52v), the first of fourteen psalms
recited in the pre-dawn prayer service of Matins on Tuesdays. The subject of the initial

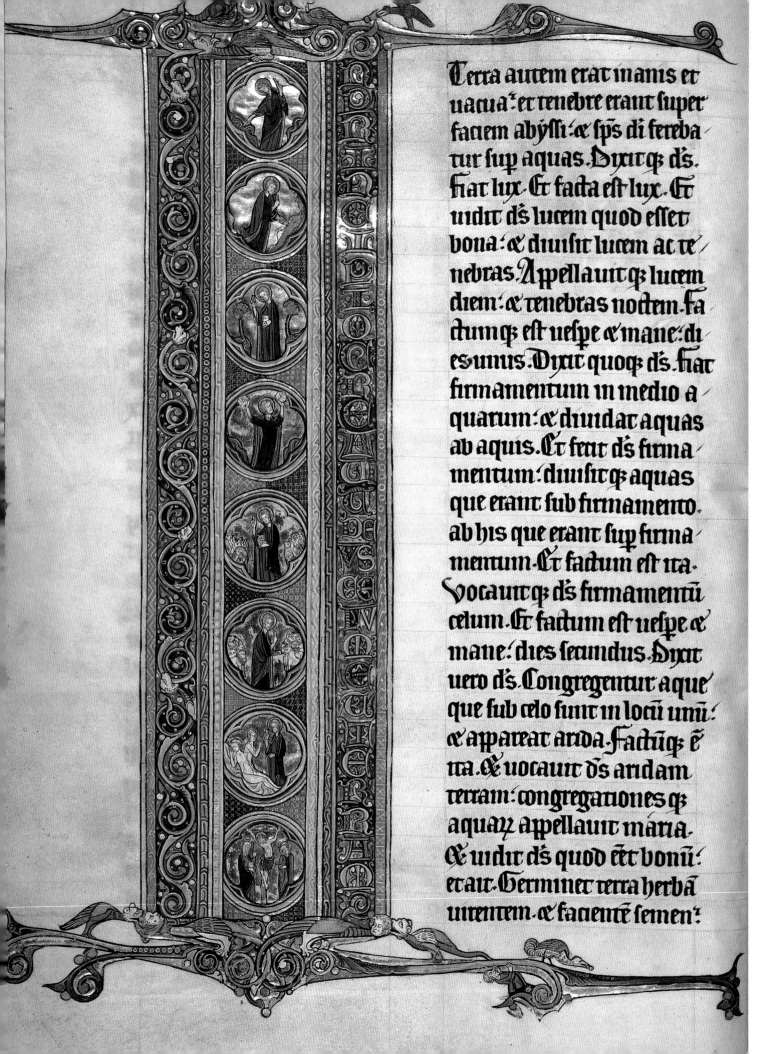

Terra autem erat inanis et
uacua: et tenebre erant super
faciem abyssi: & sps di fereba
tur sup aquas. Dixitq; ds.
fiat lux. Et facta est lux. Et
uidit ds lucem quod esset
bona: & diuisit lucem ac te
nebras. Appellauit q; lucem
diem: & tenebras noctem. Fa
ctumq; est uespe & mane: di
es unus. Dixit quoq; ds. fiat
firmamentum in medio a
quarum: & diuidat aquas
ab aquis. Et fecit ds firma
mentum: diuisitq; aquas
que erant sub firmamento.
ab his que erant sup firma
mentum. Et factum est ita.
Vocauitq; ds firmamentu
celum. Et factum est uespe &
mane: dies secundus. Dixit
uero ds. Congregentur aque
que sub celo sunt in locu unu:
& appareat arida. Factuq; e
ita. Et uocauit ds aridam
terram: congregationes q;
aquax appellauit maria.
Et uidit ds quod eet bonu.
et ait. Germinet terra herba
uirentem. & facientem semen:

was chosen according to the word (*ad verbum*) of the psalm, which opens "I said: I will take heed to my ways that I not sin with my tongue." King David, purported author of the psalms, points to his mouth with his right hand, a direct visualization of his promise to avoid sinning with his tongue. It is less clear why David points to the ground with his other hand. Perhaps this gesture alludes to the psalmist's eventual burial, for the psalm refers to the "numbering of the days" and the "passing" of its author.

The scene within the initial is complemented in the *bas-de-page* (literally, "bottom of the page"), where a seated woman points to a soldier who looks back at her as he points over to the facing page. The glances and gestures of all the figures, together with the vignette of the dog chasing a hare in the upper margin, lead the eye around the page, infusing the ensemble with an energy that undoubtedly pleased the manuscript's thirteenth-century aristocratic owner as much as it does the twentieth-century museum visitor. ECT

16 Marquette Bible
Probably Lille, circa 1270

3 volumes, 273 leaves,
47 x 32.2 cm (18½ x 12¹¹⁄₁₆ in.)
Ms. Ludwig I 8; 83.MA.57

Plate: Initial *I* with *Scenes of the Creation of the World and the Crucifixion,* vol. 1, fol. 10v

The Bible, understood to be the written word of God, is the central holy book of Christianity. Comprising Jewish sacred writings, the four Gospel accounts of Jesus' life, the letters of Saint Paul, and other texts, it is a very long book indeed. Manuscripts of the Bible were generally multivolume, large-format books designed for use at a lectern until the rise of the universities created a demand among students for small-format, portable Bibles. At around the same time, the writing and embellishment of Bibles became less and less the work of monks and more and more the activity of lay artisans.

In thirteenth-century France, the traditional large-scale format was retained at the same time that "pocket Bibles" were mass-produced in the university city of Paris. The Museum's Marquette Bible is one of several artistically related lectern Bibles made for religious institutions in northeastern France and illuminated by teams of lay artists. The Marquette Bible's illumination takes the form of historiated initials. Originally, the Bible must have had around 150 painted initials (of which 45 survive). It is hardly surprising, given the size of the undertaking, that scholars have identified the work of six different artists among the surviving initials, and we can well imagine that the team of illuminators responsible for the original seven-volume Bible was larger still.

The main artist of the Marquette Bible painted most of the initials in the early part of the text, including the glorious Genesis initial (vol. 1, fol. 10v). This initial introduces not only the book of Genesis but also the Bible as a whole; the series of scenes of Creation (as told in Genesis) ends with the New Testament scene of the Crucifixion. This combination highlights the Christian belief that Christ's death restored the world's communion with God, lost when Adam disobeyed him by eating the fruit of the Tree of Knowledge in the Garden of Eden. ECT

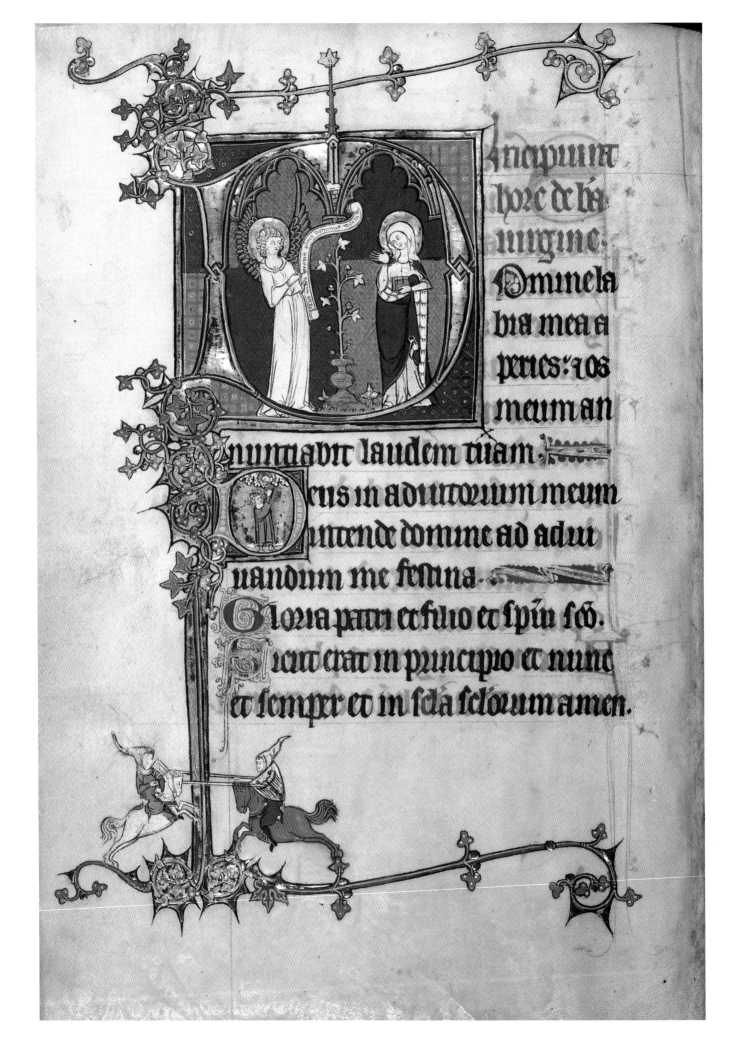

ncipiūt
hore de bā
urgine.
Ominela
bia mea a
pries: 7 os
meum an
nunciabit laudem tuam.
eus in adiutorium meum
ntende domine ad adui
uandum me festina.
Gloria patri et filio et spū scō.
icut erat in principio et nūc
et semper et in scla sclorum amen.

17 Ruskin Hours
 Northeastern France, circa 1300

128 leaves, 26.4 x 18.4 cm
(10⅜ x 7¼ in.)
Ms. Ludwig IX 3; 83.ML.99

Plate: Initial *D* with *The Annunciation,*
fol. 37v

By the fourteenth century, the book of hours replaced the psalter as the most important text for the daily personal devotions of the Christian faithful. It takes its name from the Hours of the Virgin, the book's core text. These prayers are organized for private recitation at the canonical hours, eight appointed times of the Church day. During the later Middle Ages in particular the Church encouraged the growth of private prayer and meditation among the laity. The rise in this practice and the expansion of wealth led to a demand on the part of the aristocracy and the burgeoning merchant class for fancy, decorated prayer books. Northern France was one of the prosperous regions where prayer books flourished. Not only Parisian workshops but others located throughout the north in towns like Lille, Cambrai, and Douai profited from the demand for devotional books.

Following the traditional iconography of the Hours of the Virgin, the illuminator of this large prayer book has illustrated each of the eight hours with an episode from Mary's life. For Matins, the first hour, he has depicted the Annunciation to the Virgin Mary inside the initial. All the decoration on this page springs from the large *D* in winding, spiraling, and elongated vines, an exuberant visual complement to the text's joyful opening words taken from Psalm 50: "O Lord, open my lips, and my mouth shall proclaim your praise." The smaller initial *D* shows a devout young man dressed in a simple tunic, raising his eyes in prayer to a receptive God. Figures in prayer offer similar models of devotion throughout the book's borders and smaller initials.

The jousting soldiers in the border reflect a popular aristocratic pastime of the day. Such marginal figures, clearly motifs to charm and amuse the viewer, occasionally appear to comment, sometimes humorously, on devout themes. Often, as is the case here, their relationship to the book's central religious imagery is not obvious.

This book belonged to the influential English art critic John Ruskin (1819–1900), who delighted above all in the rhythmic extenders of the book's historiated initials. He extolled them as "bold" and "noble." TK

corpore magnitudine.
Na circa lenitas p 40
elephantes solito more e
dunus delirescens. colla
eor sue modis alligat.

ac lutocarios punit.
Gignut i ethyopia
z in india. t ipo iden
dio iugit retus
De belua que dicit ocui

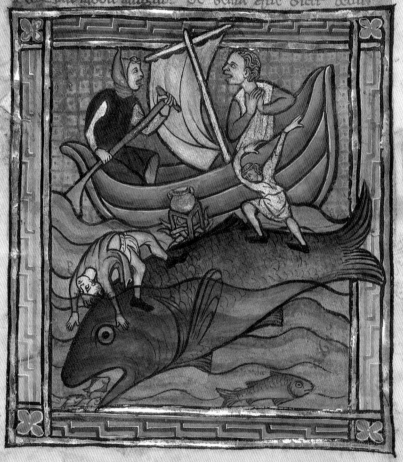

18 Bestiary
 Flemish, circa 1270

102 leaves, 19 x 14.4 cm
(7½ x 5⅝ in.)
Ms. Ludwig XV 3; 83.MR.173

Plate: *Two Fishermen, Believing Themselves at an Island, Make Their Camp on the Back of a Sea Creature,* fol. 89v

The bestiary, or "book of beasts," was one of the most popular books in the twelfth and thirteenth centuries, when its text was increasingly expanded, translated into various vernacular languages, and profusely illustrated. This allegorical interpretation of real and imaginary animals was based principally on the *Physiologus,* a Greek text written in the first centuries of the Christian era and translated into Latin in the fourth century.

From the start, such works were not scientific in the modern sense—they were more interested in drawing moral lessons than in providing objective investigation. While embracing the philosophy that the observation of the physical world leads to an understanding of heavenly operations, the *Physiologus* innovatively imbued pagan material with new Christian interpretations. The bestiary that took form at the end of the twelfth century incorporated many other early medieval sources into its text, above all material from the seventh-century encyclopedia of Bishop Isidore of Seville.

The treatment of the large sea creature called the *aspidochelone* is typical. One characteristic of the animal is that it floats with its huge back emerging above the waves, remaining motionless for long periods of time. After sand has settled there and vegetation has grown, sailors mistake the beast for an island and beach their ships on it. When the sailors light their campfires, the monster feels the heat and plunges suddenly into the watery depths. In this miniature, the artist succinctly captures all the dramatic potential of the story. While the sailors react in distress to the great beast's dive, one victim tumbles over to certain death; the fate of the man clinging tenuously to the boat hangs in the balance.

The *aspidochelone* is understood allegorically as the wily devil who deceives sinners, plunging them into the fires of hell. Similarly, the little fish that swim into the creature's mouth, attracted by the sweetness of its breath, are understood as those who are easily tempted and so swallowed by the devil. This kind of moralizing was standard in the bestiary and related texts, many of which were written by and for monks. ASC

19 Antiphonal
 Bologna, late thirteenth century

243 leaves, 58.2 x 40.2 cm
(22^{15}/$_{16}$ x 15^{13}/$_{16}$ in.)
Ms. Ludwig VI 6; 83.MH.89

Plate: Master of Gerona, Initial *A*
with *Christ in Majesty,* fol. 2

Splendidly illuminated choir books, large enough to be seen by a group of singers, stood open on lecterns in Christian churches throughout Western Europe during the High Middle Ages and Renaissance. The two principal types of choir book are the antiphonal and the gradual. An antiphonal contains the chants of the divine office—the eight prayer services celebrated daily by monks, nuns, and clerics of the Catholic Church. The musically elaborate portions of the mass—the Christian rite in which bread and wine are consecrated and shared—are found in a gradual.

The illumination of choir books primarily takes the form of historiated initials. The first and most impressive initial in this antiphonal is an *A* with *Christ in Majesty* (fol. 2). Its subject was inspired by the chant it introduces, which relates that the speaker "sees the coming power of the Lord." This "coming power" is understood in a Christian context as the return of Christ at the end of time, when he will sit in judgment of all humanity. The prophet Isaiah (whose words provided the inspiration for the text of the chant) "sees" Christ from the roundel at the lower left.

The illuminator of this antiphonal was well versed in the most recent trends in panel painting. His style resembles that of the Florentine painter Cimabue (circa 1240–1302[?]), who was described by the first historian of Italian art, Giorgio Vasari (1511–1574), as the *prima luce* (first light) of painting. Vasari thus saw Cimabue as standing at the beginning of a new development in Italian art that culminated in the work of the High Renaissance artist Michelangelo. Like Cimabue, the Master of Gerona was profoundly influenced by Byzantine icon painting but also made great strides in naturalistic representation, as evidenced in this spatially ambitious composition of Christ enthroned with standing angels. ECT

appropinquauit. ps. Beat'

℣. Et syon speci es decoris cus.
deus noster maniste ueniet.

uir. euouae.

℟.

spiciens

alon ge

ecce

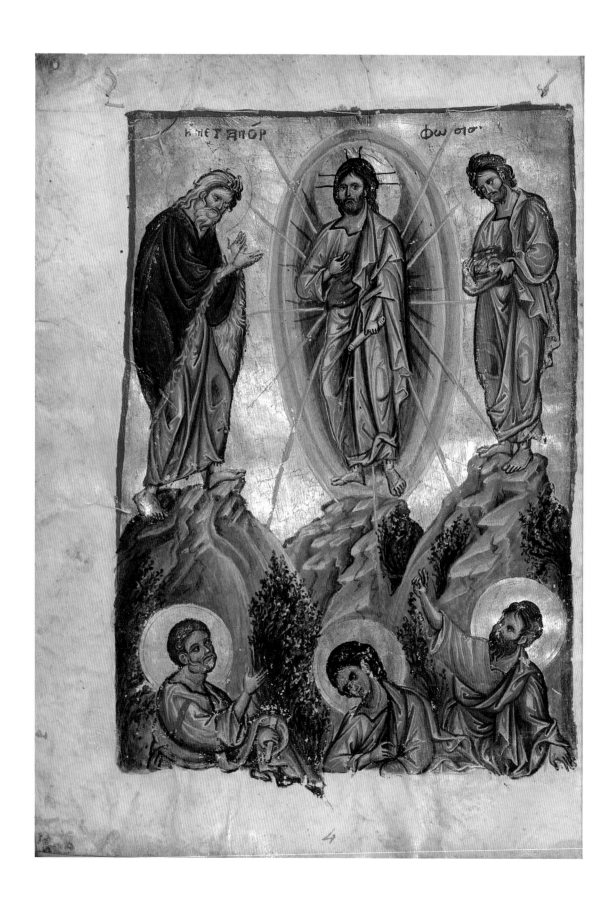

20　Gospel Book
　　Nicaea or Nicomedia,
　　early and late thirteenth century

241 leaves, 20.5 x 15 cm
(8⅛ x 5⅞ in.)
Ms. Ludwig II 5; 83.MB.69

Plate: *The Transfiguration,* fol. 45v

With the sack of Constantinople in 1204 by Crusaders from Western Europe, Byzantine political administration shifted away from the imperial capital now dominated by the invaders. Based on artistic and paleographic comparisons with other manuscripts, the Getty Museum's Gospel book can be dated to this critical moment in European history. The specific place of its origin has not been determined; Nicaea (modern Iznik), Nicomedia (Izmit)—both not far from Constantinople—and Cyprus have all been suggested as possibilities. The manuscript is thus an important witness to the continued artistic production in the Byzantine provinces at a time of political disruption.

This *Tetraevangelion* (the Greek term for a Gospel book) contains nineteen full-page illuminations: four evangelist portraits and fifteen images illustrating various key feast days in the Christian calendar. Only the evangelist images and two feast pictures can be dated to the beginning of the thirteenth century, however, while the other thirteen images were painted toward the end of the same century. These later pages were inserted as replacements for a portion of the earlier cycle that had deteriorated over the course of the 1200s. Byzantine manuscript painters often coated the bare parchment with egg white, which originally had the effect of giving the page a slick and glossy appearance, but which also led to extensive paint flaking in the miniature. The problem was sufficiently common that Planudes, head of a monastic scriptorium, wrote in a letter of 1295:

> For if the parchment leaves should somehow see water, the writing on them
> erupts and quakes with the egg, and the work of the scribe turns out into thin
> air, clean gone.

The miniature of the Transfiguration is representative of the later Palaeologan style that flourished after the Crusaders were expelled in 1261. Named after the imperial family and lasting well into the fifteenth century, this style features large-scale figures based on earlier Byzantine models enlivened by dramatic gestures and an intensity of feeling. *The Transfiguration* and the other Palaeologan images can be dated to around 1285, but, like the earlier miniatures of the book, the place of their production remains uncertain.　　　　　　　　　　　　　　　　　　　　　　　　　　ASC

21 Two Miniatures from a Book of
Old Testament Prophets
Sicily, circa 1300

7.3 x 17.4 cm (2⅞ x 6⅞ in.)
Ms. 35; 88.MS.125

Plate: *The Vision of Zechariah,* leaf 2

Since the Renaissance some collectors have prized older illuminated manuscripts more for their decoration than for their texts. Thus at a time when bibliophiles still actively commissioned new illuminated manuscripts, other collectors would cut the miniatures and other painted decoration from older books. The practice continued for centuries. In the late eighteenth century the Basel art dealer Pieter Birmann assembled an album of 475 cuttings from scores of medieval manuscripts of all types. The Getty Museum owns two miniatures from that album; the other represents *The Assassination of Sennacherib.* They probably derive from a book of Old Testament prophets.

The rare subject illustrated here is the first of Zechariah's eight visions. A translation from the Latin Vulgate Bible, which was the likely source for the illuminator, reads:

> I saw by night, and behold a man riding upon a red horse, and he stood among the myrtle trees that were in the bottom and behind him were horses, red, speckled, and white. And I said: "What are these, Lord?" and the angel that spoke in me said to me: "I will show you what these are:" And the man that stood among the myrtle trees answered, and said: "These are they, whom the Lord has sent to walk through the earth." And they answered the angel of the Lord, that stood among the myrtle trees and said: "We have walked through the earth and behold all the earth is inhabited and at rest."
>
> (Zechariah 1:8–11)

The artist departs from the mystical text by showing the man in the vision mounting one of the horses rather than simply standing among the myrtles, by showing one red horse instead of two, and by showing the angel at Zechariah's side.

The elongated proportions of the figures and their small heads are particularly characteristic of this moment in Byzantine art. Textual and paleographic evidence, however, suggests that the illuminator, even though he was probably Greek, painted these miniatures in a book written in Western Europe. Such an artist would have resided most likely within the Greek communities of Sicily. TK

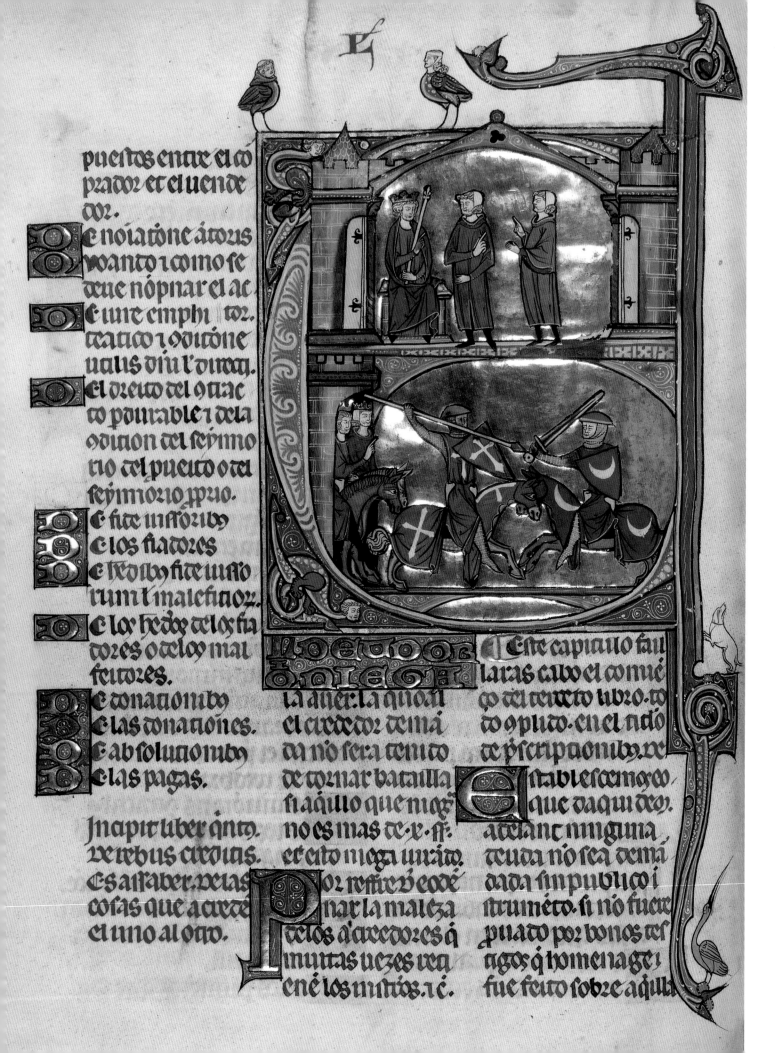

puestos entre el co
prador et el uende
dor.

e noiatõe a tous
uoanto i como se
deue nopnar el ac.

E iure emphi tor.
teatico i oditõe
utalis diu l'diuet.

el dreito del gtrac
to pointable i dela
oditon del seyimo
tio del puedo o del
seyimorio p'puo.

e fite iiii fioribz

e los fiadores

e fedibz fite iiifto
rum l malefitioz.

e lor hedz delos fia
dores o delos mal
feitizes.

e tonatioiubz

e las tonationes.

e absolutioiubz

e las pagas.

Jnapit liber qnto
de rebus crediris.
Es a saber. delas
cosas que a crede
el uno al otro.

la auer. la qual fi
el crededor demã
da nõ sera tenido
de tornar batailla
si aqllo que neg
no es mas de. x. ff.
et esto niega iuraro.

Por refire bz eode
par la maleza
dlos acredores q
muitas uezes req
ene los muitos. i c.

Este capitulo fau
laras a luo el conue
ço del terceto libro. to
do o pluto. en el ticõ
de p'scripaonibz. ve

Establescemos
que daqui dea.
atelant ninguna
teuda nõ sea demã
dada sin publico i
strumeto. si nõ fuer
p'uato por bonos tes
tigos q homenage i
fue feito sobre aqll

22 *Vidal Mayor*
Northeastern Spain,
circa 1290–1310

277 leaves, 36.5 x 24 cm
(14 ³⁄₈ x 9 ⁷⁄₁₆ in.)
Ms. Ludwig XIV 6; 83.MQ.165

Plate: Initial *E* with *An Equestrian
Duel Between a Creditor and Debtor,*
fol. 169v

In 1247, with the reconquest of Spain from the Moslems virtually complete, King James I of Aragon and Catalonia (r. 1214–1276) determined to establish a new systematic code of law. He entrusted the task to one of the leading court figures, Vidal de Canellas, Bishop of Huesca, who had studied law in the famous University at Bologna. Vidal formulated two versions in Latin, and the larger is commonly called the *Vidal Mayor*.

The original Latin *Vidal Mayor* no longer exists, and the Getty Museum's manuscript is the only known copy of the code, preserved in a vernacular Navarro-Aragonese translation. It is thus a critical document of the laws and feudal customs of Aragon. Of particular interest are the cases that deal with Moslems and Jews, as well as with the different classes of Christian society. The *Vidal Mayor* shows clearly, in word and image, that the king's law was applicable to all the inhabitants of the realm.

The historiated initial that opens Book 5 suggests this historical context of the *Vidal Mayor*. This section deals with issues of credit, and the scene depicts a dispute and ensuing duel between a creditor and debtor in the presence of the king. The prominently displayed heraldic devices seem to indicate that the contest is between a Christian and a Moor. The crescent would have called to mind a symbol of the Spanish Moslems, though in this manuscript it may simply be used as a reference to a "foreigner."

With 156 historiated initials, the *Vidal Mayor* is unsurpassed in early fourteenth-century Spanish book illumination. The distinctive style of the figures, the predominance of red, blue, and gold, and the types of animals and beasts used to embellish the initials are all elements of French Gothic art (nos. 14–17). The manuscript was likely produced in one of the major urban centers of northeastern Spain, perhaps Barcelona or Pamplona, by a French artist or perhaps by one trained in Paris or northern France. The scribe of the book, Michael Lupi de Çandiu, may also have been responsible for the translation of the text. ASC

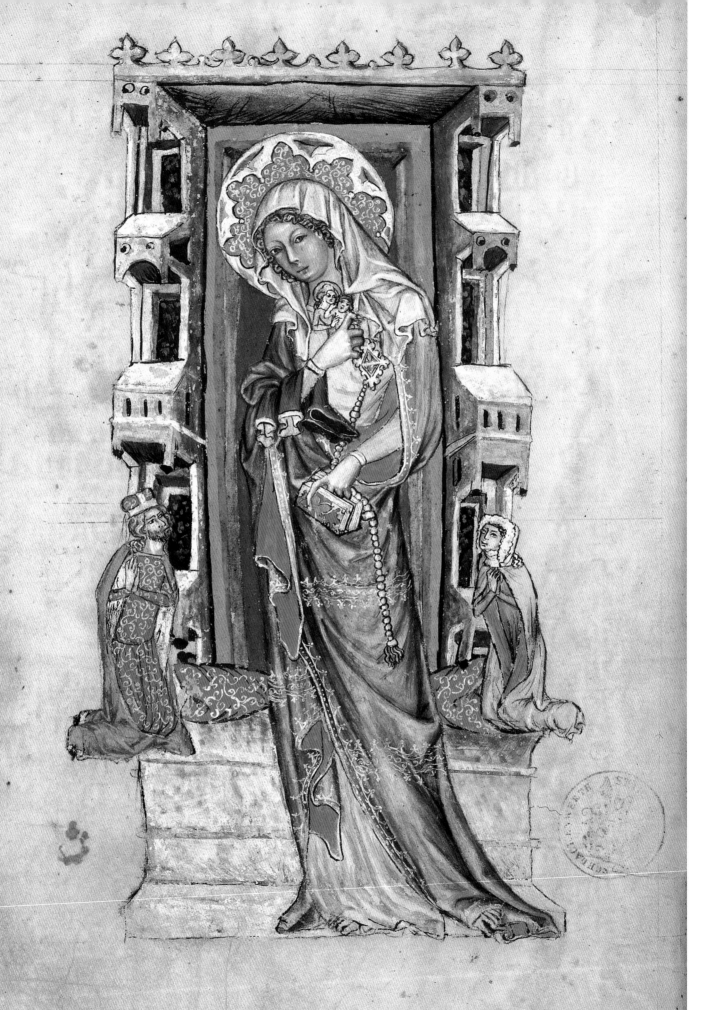

23 *Vita beatae Hedwigis*
Silesia, 1353

204 leaves, 34.1 x 24.8 cm
(13⁷/₁₆ x 9¾ in.)
Ms. Ludwig XI 7; 83.MN.126

Plate: *Saint Hedwig of Silesia Adored
by Duke Ludwig of Legnica (Liegnitz)
and Brzeg (Brieg) and Duchess Agnes,*
fol. 12v

The *Life of the Blessed Hedwig* manuscript is a key monument of Central European painting in the fourteenth century. It is the earliest extant illustrated account of the holy Silesian noblewoman Hedwig, who lived from 1174 to 1243 and was canonized in 1267, a remarkably short time after her death. The text and interspersed illuminations reveal much not only about Hedwig's life but also about female spirituality in the High Middle Ages. Unlike early Christian saints, who were typically chaste martyrs, saintly women of the later medieval period were often devoted wives and mothers. Hedwig's deeds, focusing on intense prayer, physical mortification, and extraordinary acts of charity, illustrate various channels used by medieval women to relate spiritually to Christ.

The frontispiece portrays the richly attired saint as a widow with attributes relating to her holy life: the statuette of Mary refers to Hedwig's devotion to the Virgin, the book and rosary to her numerous prayers, and her bare feet to an ascetic existence. The execution of the page reflects the latest style in Bohemian painting, which flourished in the mid-fourteenth century under the Holy Roman Emperor Charles IV. The gently curving figure of Hedwig is vigorously modeled and painted in a manner reminiscent of Central European polychrome sculpture, which also recalls the elegance of contemporary French Gothic art.

The saint stands before her throne, towering over the adoring Duke Ludwig and Duchess Agnes, who commissioned this manuscript. Ludwig, a fifth-generation descendant of Hedwig, was politically a relatively minor Silesian duke but an ambitious patron of building and artistic programs. The manuscript was intended as a monument to the duke's glorious family history and was originally destined for the nunnery in Legnica founded by the saint herself. According to Ludwig's will of 1396 (two years before his death), the codex was sent instead to the so-called Hedwig Convent in Brzeg that the duke had established. The book's text and illustrations would have provided the nuns with a model for their own behavior. ASC

24 Guiart des Moulins,
Bible historiale
Paris, circa 1360–1370

2 volumes, 608 leaves, 35 x 26 cm
(13¾ x 10¼ in.)
Ms. 1; 84.MA.40

Plates: Master of Jean de Mandeville,
The Birth of Esau and Jacob, vol. 1,
fol. 29v
Joseph in the Well, vol. 1, fol. 39
King David with Musical Instruments,
vol. 1, fol. 273
The Fool and a Demon, vol. 1, fol. 284

The Bible in its entirety did not become widely accessible in the vernacular until the fourteenth century. In France it was known largely through an extravagantly adulterated version called the *Historical Bible.* Compiled at the end of the thirteenth century by the cleric Guiart des Moulins, it began as a translation of the *Historia scholastica* (Scholastic History) written in Latin by another Frenchman, Peter Comestor (circa 1100–1179). Peter's book stressed the role of scripture as a record of historical events. It consists of his commentary upon excerpts from the Bible. To his translation of the *Scholastic History,* Guiart added further commentary and translations of complete books of the Bible. Even before Guiart's death (by 1322) his book began to appear in an expanded version, supplemented by French translations of all the Bible's books and some of the apocrypha that he had not translated. In the end it had grown to resemble a complete Bible with the addition of commentaries, apocryphal writings, and devotional texts. Like Peter, Guiart emphasized the historical narrative.

The distinctive technique of painting called grisaille (literally "gray" or "painting in tones of gray") enjoyed as much popularity in fourteenth-century France as the

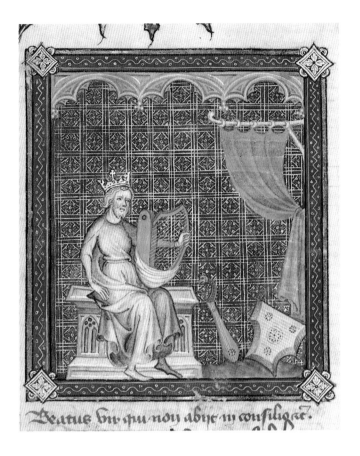

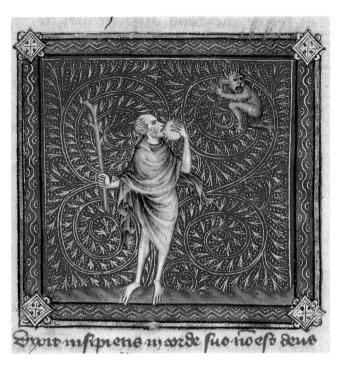

Historical Bible. In this manuscript the costumes of the figures are painted gray while faces and hands are rendered in flesh tones and touches of color. Found throughout French books of this era, the technique attracted many illuminators during the successive reigns of King John the Good (r. 1350–1364) and Charles V (r. 1364–1380) in particular. The brightly patterned backgrounds of the miniatures underscore the three-dimensionality of the delicately drawn, palely colored figures.

Bibles and *Bibles historiales* were often embellished with scores of illuminations. The Getty two-volume example has seventy-three miniatures, their subjects mostly taken from the Old Testament. The first two shown here illustrate scenes from Genesis, the birth of Esau and Jacob and Joseph tossed by his brothers into a well. The next two illustrate the psalms. Artists often introduced the psalms with the scene of King David playing his harp. The fool taunted by a demon illustrates Psalm 52, which begins: "The fool says in his heart 'There is no God.'" TK

25 Missal
Bologna, between 1389
and 1404

277 leaves, 33 x 24 cm (13 x 9⁷⁄₁₆ in.)
Ms. 34; 88.MG.71

Plate: Master of the Brussels Initials,
*The Calling of Saints Peter and
Andrew,* Initial *D* with *Saint
Andrew,* and Initial *Q* with *Saint
Peter,* fol. 172a

A missal contains the texts of the mass, which has as its focus the celebration of Holy Communion. The book has several sections. Masses celebrated on Sundays and on feast days commemorating events in the Life of Christ are collected in the Proper of Time (*temporale*). The feast days for individual saints are collected in the Proper of Saints (*sanctorale*). The latter opens with the feast of Saint Andrew (November 30) and is illustrated here by *The Calling of Saints Peter and Andrew,* in which Christ sees the two men in a boat casting their nets in the Sea of Galilee. They join him, becoming the first of the apostles. The initials *D* and *Q* show, respectively, Saint Andrew holding the cross on which he was crucified and Saint Peter holding the key to heaven.

Bolognese illumination blossomed during the thirteenth and fourteenth centuries, due in part to the rise of the book trade in the university town. This book's anonymous illuminator, the Master of the Brussels Initials, was a student of Niccolò da Bologna (circa 1330–1403/4), one of the finest Italian illuminators of the fourteenth century. The strong local colors, the intensity of the holy men's gazes, and their bulky robes probably reflect the influence of Niccolò. On the other hand the border teeming with drolleries, beasts, and acanthus leaves is this master's own innovation. Within a decade of painting the missal the Master of the Brussels Initials moved to Paris, where he became a major figure in the French International style of manuscript illumination. His distinctive style of decorative borders was widely imitated there.

Cardinal Cosimo de' Migliorati (circa 1336–1406) commissioned this book before his election to the papacy in 1404 as Innocent VII. His arms in the lower margin are overpainted with the papal tiara and arms of the Antipope John XXIII (d. 1419), who was elected pope in 1410 and deposed in 1415. Both were pope during the Great Schism of the West (1378–1417), when a second pope resided simultaneously in Avignon.

TK

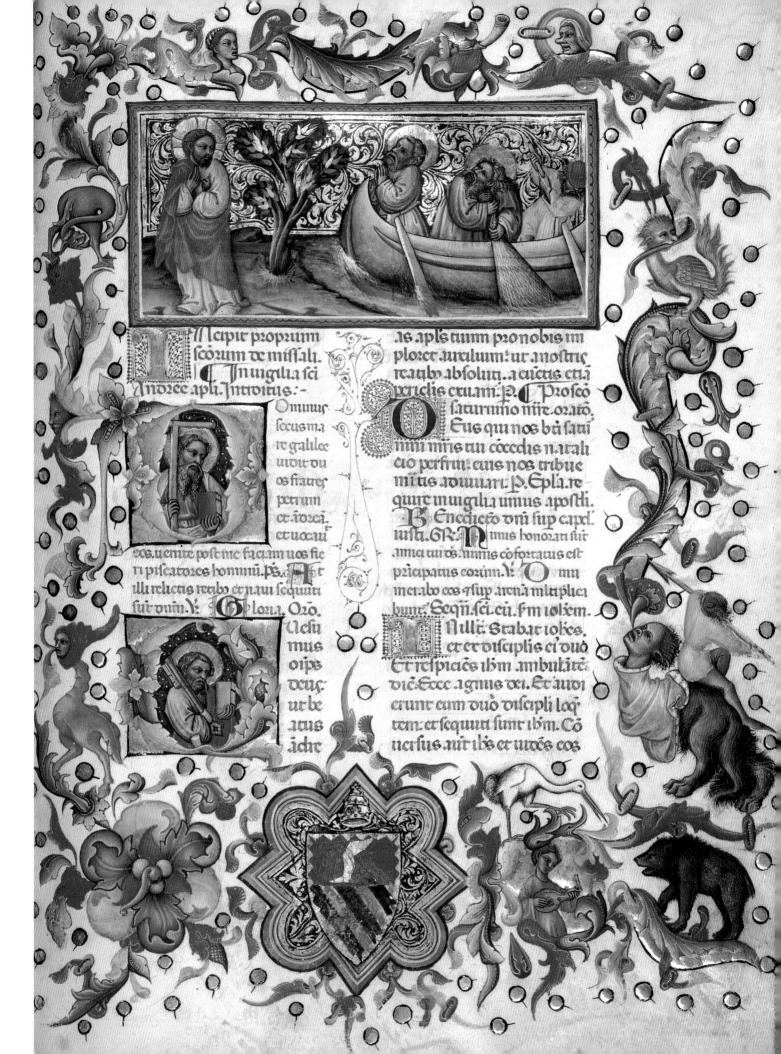

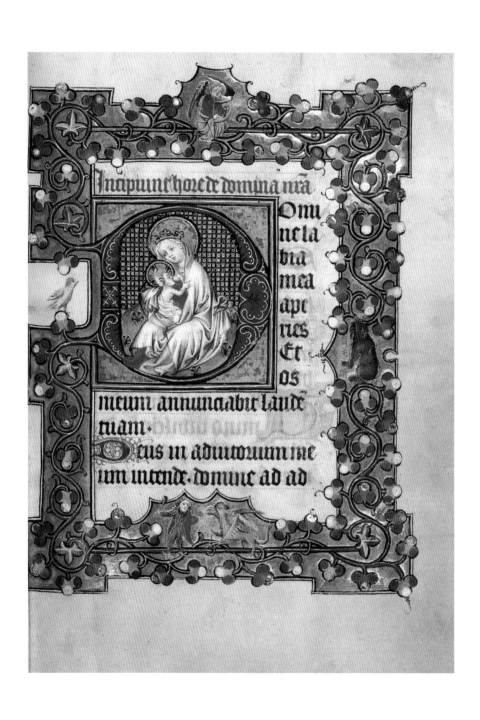

Incipiunt hore de domina nra

Domi
ne la
bia
mea
ape
ries
Et
os

meum annunciabit laude
tiam·
Deus in adiutorium me
um intende· domine ad ad

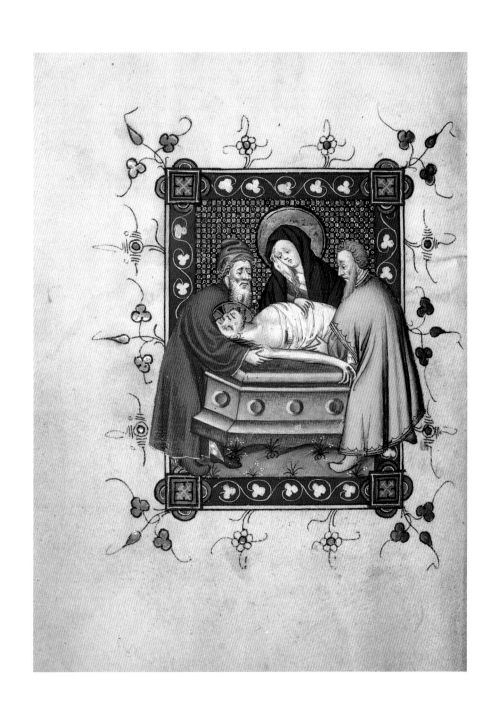

26 Book of Hours
Probably Utrecht,
circa 1405–1410

210 leaves, 16.4 x 11.7 cm
(6½ x 4⅝ in.)
Ms. 40; 90.ML.139

Plates: Masters of Dirc van Delf,
Initial *D* with *Madonna and Child,*
fol. 14
The Entombment, fol. 79v

See pages 64–65

The transition from the fourteenth to the fifteenth century saw a continuous flowering of manuscript illumination in the farthest corners of Europe. One of the newest centers was the northern Netherlands (modern Holland), where a style of court illumination blossomed under the benevolent patronage of Albrecht of Bavaria, Count of Holland (r. 1389–1404). Gathering artists, musicians, and intellectuals at his court in The Hague, Albrecht engaged the eminent Dominican theologian Dirc van Delf as court chaplain while commissioning illuminated copies of Dirc's writings. Called, suitably, the Masters of Dirc van Delf by scholars, several of these anonymous artists illuminated this book of hours. The Masters of Dirc van Delf formed one of the first important illuminators' workshops of fifteenth-century Holland. Because of the workshop's association with the court chaplain and the origins of its art in painting at Albrecht's court, it seems likely that a member of Albrecht's family or one of his courtiers commissioned the Getty manuscript.

The Hours of the Virgin open with an image of the Virgin and Child. She is shown crowned as Queen of Heaven, but seated on the ground, a reflection of her humility and thereby an example for the reader. Her sweet, youthful face, the full modeling of the amply robed body, and the soft lighting are characteristics of painting and illumination in Northern Europe at this time. (Compare, for example, no. 28, painted not far away in Cologne.)

Books of hours not only fostered devotion to the Virgin Mary but also provided meditations on the meaning of the story of Christ. As this manuscript illustrates, their miniatures complement the texts, engaging the emotions and fostering empathy with Jesus for his supreme sacrifice. In *The Entombment,* the Virgin, Joseph of Arimathea, and Nicodemus, their eyes filled with sadness, gently lay Christ's body into the tomb. The Virgin contemplates her son's face and with it the meaning of his death, just as the viewer is invited to use this image to meditate on the same truths. The artists show the caretakers' broad forms extending beyond the confines of the painted frame; by implication they move closer to the viewer's experience. TK

27 Rudolf von Ems, *Weltchronik*
 Regensburg, circa 1400–1410

309 leaves, 33.5 x 23.5 cm
(13³/₁₆ x 9¼ in.)
Ms. 33; 88.MP.70

Plates: *The Construction of the Tower
of Babel,* fol. 13
*The Israelites' Fear of the Giants and
the Israelites Stoning the Spies,* fol. 98v

See pages 68–69

Rudolf von Ems, a German knight and a prolific writer, composed his *World Chronicle* toward the middle of the thirteenth century. Left uncompleted at his death around 1255, the *Weltchronik* sought to trace history from Creation to the present. The chronicle depended to a large extent on the events of the Bible for its narrative, as is evident from its division into six ages—Adam, Noah, Abraham, Moses, David, and Christ. Rudolf's text, which comprises some thirty-three thousand lines of rhymed German verse, ends in the middle of the story of King Solomon.

Rudolf moved away from the courtly romances and lyrics that characterized Middle High German literature and returned to the tradition of writing more sober history. Interwoven with his biblical narrative is information relating to the Trojan War and Alexander the Great, to name but two examples. Rudolf's *Weltchronik* enjoyed an unusual popularity and was itself used as a model for later vernacular chronicles.

This early fifteenth-century manuscript is one of numerous illustrated copies of the *Weltchronik* and contains other historical texts, including a *Life of the Virgin Mary*. Of the volume's almost 400 miniatures, 245 illustrate incidents in Rudolf's work. *The Construction of the Tower of Babel,* showing King Nimrod at left supervising the operation, depicts a variety of building procedures that probably mirror medieval practices closely. In an episode from the Book of Numbers (chapters 13–14), the Israelites react to the news brought by the twelve spies that the land of Canaan is inhabited by giants, represented here as contemporary knights. While some engage in animated debate, others seek to stone Joshua and Caleb, the two spies who voiced their faith in God's providence. The art in this German *Weltchronik* is characterized not only by vivid coloring and bold brushwork but also by the agitated movement and the psychological intensity of the figures. These features stand in contrast to the jewel-like color, courtly dress, and demure physical types of the International style that flourished in European painting and manuscript illumination at the beginning of the fifteenth century (nos. 25–26, 28–32). ASC

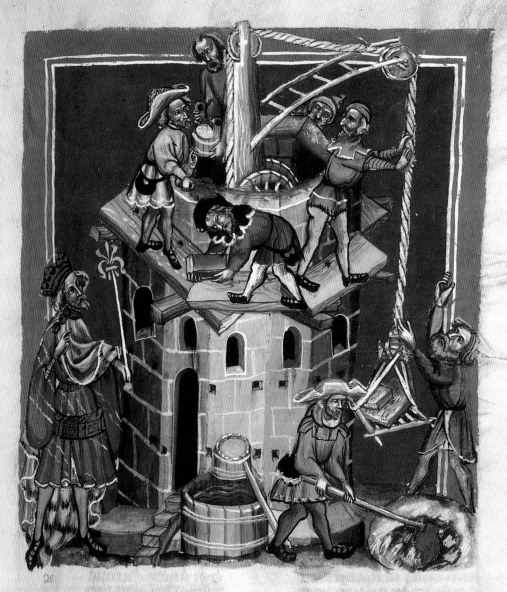

In diſen ſellen ſtunden ſter dann funftauſent ſchrit hoch
Des werches ſi legunden Vnd ſibenzig vñ nawn hundert
Vnd heten in der tage zil vnd vier ſchrit auz geſundert
Des werches gächs alſo vil ſur zwain vñ ſibenzig ekken waz
Gemachet daz es ſich gezoch Der ſelb turn alz ich es laz

Ir heren funden ein lant
daz nieman war lehant
ein pezzer lant anderſwa
lauft vn gutes war alda
mit reichait mer danne vil
vnd koſt nach des wunſches zil
Gepawen weitenleich
daz lant war gut vnd reich
Auch heten ſi dar inn
Geleben ze vngewinn
daz geſlacht von enach
Do erſelpakt daz her vn ſprach
O we des woeltenleichen not
O we warn wir dann tot
in egypten gelegen
Seint wir vns nw muzze bewege
daz wir ligen tot von diſen
landigen vngehewrn riſen
daz war vns paz ergangen

Lan daz vns nw gevangen
werdent dort weib vnd chint
Dy von vns gepern ſint
Vnd erweſen einen hauptman
Des vns fur wider dan
Caleph vnd toſue
went tot ir zwerfel red we
vn alſo we daz ſi zehant
Ab in zarten daz gewant
von des zwerfels marn
Den tumben zwerfelarn
Straften ſi ir mas do
vn ſprachen zw in alſo
Seit nicht widerpruchig got
daz ir an ſeinem gepot
icht werdet zwerfelhaft
wir haben ſo veſt chraft
Seint den lauten dy dort ſint
daz wir ſi ezzen als ein rint
daz gras auf ainer waid tut

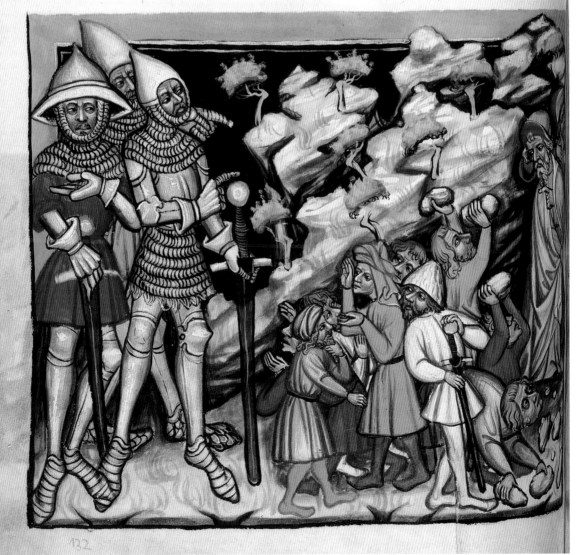

122

28 Two Miniatures, Perhaps from
 a Manuscript
 Cologne, circa 1400–1410

23.6 x 12.5 cm (9⁵⁄₁₆ x 4⁷⁄₈ in.)
Ms. Ludwig Folia 2; 83.MS.49

Plate: Master of Saint Veronica,
*Saint Anthony Abbot Blessing the
Animals, the Poor, and the Sick,* leaf 2

Cologne on the lower Rhine River was a major artistic center throughout the Middle
Ages; led by a painter called the Master of Saint Veronica (fl. circa 1390–1410), the
town produced several of the finest painters of the fifteenth century. Cologne's proximity
to Dutch and Flemish towns placed it within a nexus of burgeoning artistic creativity,
especially in painting and manuscript illumination.

The Master of Saint Veronica shows the fourth-century hermit saint Anthony
Abbot blessing the sick, the poor, and animals. He stands on a pedestal dressed in the
black mantle with *Tau* sign (*T*) and white robe of the Order of the Hospitallers of
Saint Anthony, and in stylish and costly shoes. He holds the crosier of an abbot. The
pedestal resembles the socles that support polychrome devotional carvings of saints of
the time, a reminder to the viewer that this is not merely a narrative scene. The saint
himself is an object for our veneration. The Hospitallers of Saint Anthony dedicated
their ministry to caring for the sick and infirm. One of the most widely venerated of
saints during the Middle Ages, the hermit Anthony was invoked for assistance against
various diseases, especially the one popularly known as Saint Anthony's fire (*erysipelas*).
A particularly widespread and virulent malady of the Middle Ages, erysipelas caused
gut-wrenching pain, contortions, and hallucinations. Its consequences included
amputation of limbs and inevitable death.

Cologne had an important church dedicated to Saint Anthony with a hospital
run by the order. It was rebuilt during the 1380s, less than a generation before the
Museum's miniatures were painted. By some accounts, the Abbot of Saint Anthony's
in Cologne blessed the animals on the saint's feast day each year (January 17). It
seems likely, therefore, that the Master of Saint Veronica painted this miniature and
its companion expressly for a book or small altarpiece for that church or a chapel in
the adjoining hospital.

The brilliant colors, sweet and tender facial expressions, courtly and elegant
costumes, and nuanced modeling reflect a style of painting that links such diverse
centers as Cologne, Utrecht, Paris, Prague, and London around 1400. Scholars call
this phenomenon the International style. TK

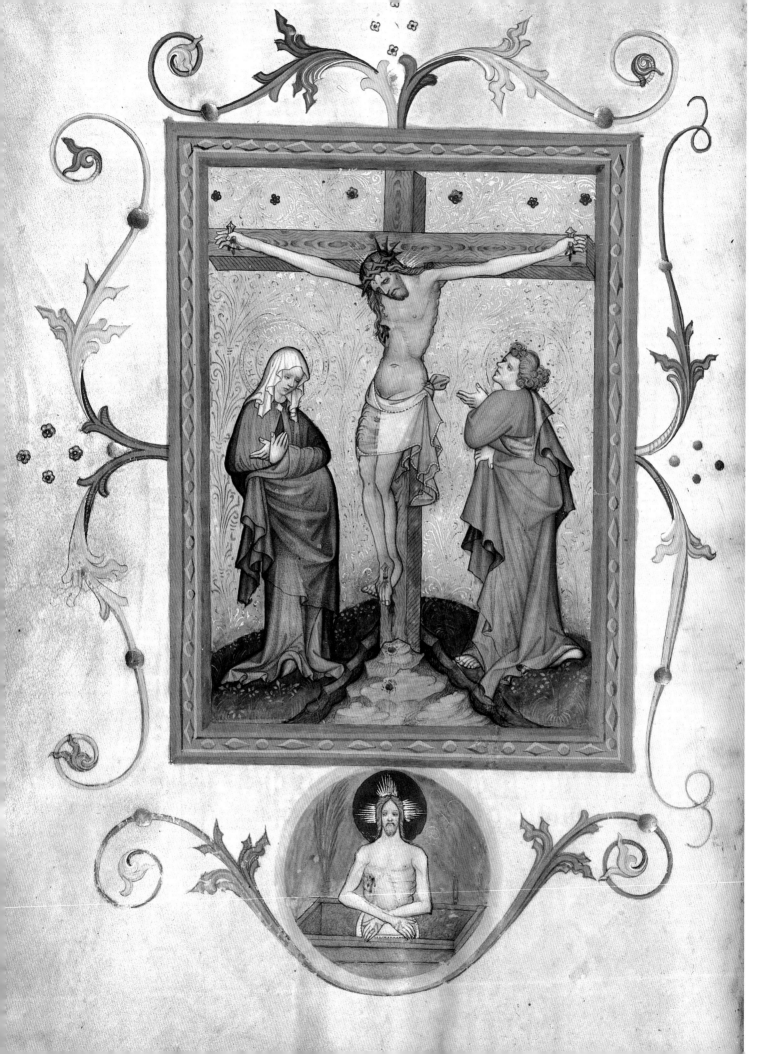

29 Missal
 from the Collegium Ducale
 Vienna, circa 1420–1430

307 leaves, 41.9 x 31 cm
(16½ x 12³⁄₁₆ in.)
Ms. Ludwig V 6; 83.MG.81

Plate: *The Crucifixion,* fol. 147v

The International style takes its name from the art that was created in such disparate European centers as Paris, Utrecht, Cologne, and Prague. The broad stylistic unity within architecture, sculpture, painting, and manuscript illumination was the result in part of the increased movement of artists who were attracted by courts with extensive ties throughout the continent. In Eastern Europe, Bohemian Prague became the leading political and cultural hub as capital of the Holy Roman Empire under Charles IV, himself raised and educated in France.

Another, less familiar, center of art production was Vienna, where this missal was made. Its painters, including an illuminator known only as Michael, have been identified from their work in other commissions from Vienna, Bohemia, and Slovakia. The missal is thus a witness to the cross-fertilization in Central European art at this time. The association of artists probably trained in Bohemia, but working together in Vienna indicates the city's increasing importance. That Viennese patrons enlisted such artists suggests, too, that they may have been seeking to compete with the powerful Bohemian court.

In this image of the Crucifixion, Jesus' drooping head, emaciated torso, and frail arms show his suffering on the cross. At the bottom of the page Jesus appears as the Man of Sorrows, the risen Christ who displays his wounds to the devout for contemplation. The juxtaposition of the two images demonstrates that resurrection and salvation are already inherent in the act of Crucifixion. The miniature simultaneously conveys a sense of refined elegance typical of the International style. This is evident first in the subdued coloring, as the delicately ornamented pink background highlights the primary blues and greens. The gentle sway of the figures and the sinuous contours of their robes are characteristic of this stage of late Gothic painting.

According to a treasury inventory written in the manuscript in 1508, the book then belonged to the Collegium Ducale. Established in 1384, this theological faculty was part of the Vienna University, which had been founded in 1365 by Duke Rudolf IV of Austria. It cannot be said whether or not the missal was originally made for the Ducal College. ASC

30 Giovanni Boccaccio,
*Des Cas des nobles hommes
et femmes*
Paris, circa 1415

318 leaves, 42.5 x 29.3 cm
(16 ¾ x 11 9/16 in.)
Ms. 63; 96.MR.17

Plate: Boucicaut Master and Workshop,
The Story of Adam and Eve, fol. 3

The Florentine poet and man of letters Giovanni Boccaccio (1313–1375) is one of the fathers of Renaissance humanism. Within a generation of his death, Boccaccio's writings were already popular outside of Italy. A number of them, including *The Decameron*—the one most read today—were translated into French under the patronage of such august figures as Philip the Bold, Duke of Burgundy (1342–1404) and John, Duke of Berry (1340–1416). In France at that time the most beloved by far was this text of *The Fates of Illustrious Men and Women*. It relates the stories of notables from biblical, classical, and medieval history. Laurent de Premierfait (d. 1418), who translated Boccaccio's works, embellished the original with many colorful tales from other authors including the ancient Romans Livy (59 B.C.–A.D. 17) and Valerius Maximus (circa 49 B.C.–circa A.D. 30).

Boccaccio begins the book with the lives of Adam and Eve, since their sin gave rise to the calamities that would befall humankind. Ingeniously organizing the sequence of events around the tall hexagonal walls of the Garden of Eden, the Boucicaut Master shows us the Temptation of Adam and Eve in the center. The first couple are driven from the garden through a portal at the left, and beyond the garden walls they assume their fates toiling in the fields and spinning. In the foreground right we see Adam and Eve, now elderly and stooped, approaching the author to tell their story. Boccaccio is elegantly robed in red. The artist has created an elaborate frame that encloses both the miniature and the opening lines of the text. It includes a sequence of painted vignettes depicting the Creation of the World, commencing at the upper right and proceeding clockwise.

The first quarter of the fifteenth century proved to be one of the most original and influential epochs of Parisian manuscript illumination, due in significant part to the genius and industriousness of the Boucicaut Master. With the aid of numerous highly trained collaborators, this artist's innovative work became known throughout Europe and influenced not only the direction of French illumination for more than a generation but that of Flemish painting as well. TK

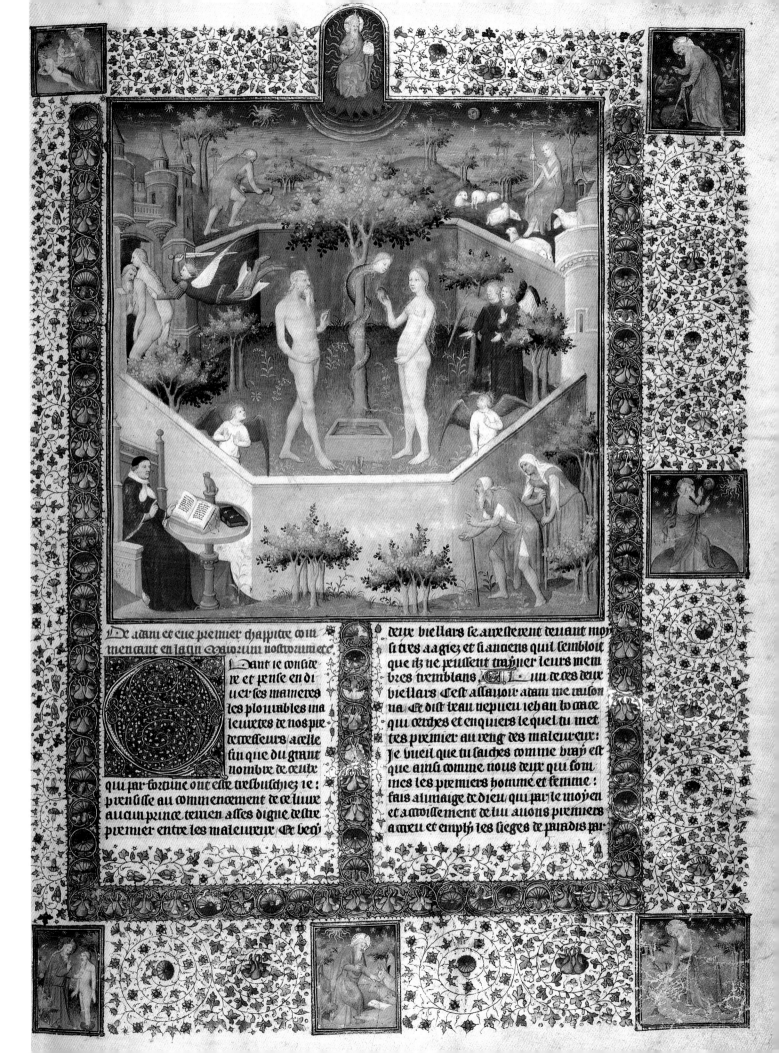

De adam et eue premier chappitre com
mencant en latin sconium nostrorum etc.

Dant le confide
re et pense en di
uerses manieres
les plourables ma
leuretes de nos pre
decesseurs/ acelle
fin que du grant
nombre de ceulx

qui par fortune ont este treluschiez ie:
prenusse au commencement de ce liure
aucun prince remen asses digne deltre
premier entre les maleureux. Et ueoi

deux bieillars se arresterent deuant mon
si tres aagiez et si anciens quil sembloit
que iz ne peussent trayner leurs mem
bres tremblans. L in de ces deux
bieillars cest assauoir adam une raison
na. Et dist trau nepueu ieh an to cause
qui cerches et enquiers le quel tu met
tes premier au reng des maleureux:
Je vueil que tu saiches comme uray est
que ainsi comme nous deux qui som
mes les premiers homme et femme:
fais alimaige de dieu qui par le moyen
et arrouisement de lui auons premiers
a meu et empli les sieges de paradis par

31 Book of Hours
 Paris, circa 1415–1420

281 leaves, 20.4 x 14.9 cm
(8¹⁄₁₆ x 5¹³⁄₁₆ in.)
Ms. 22; 86.ML.571

Plate: Boucicaut Master, *All Saints,*
fol. 257

Toward the end of the fourteenth century Eustache Deschamps (circa 1346–1406),
a poet and artist at the court of Charles VI of France, mocked the widespread demand
for illuminated books of hours among middle-class women. He held up the fashion as
a display of vanity and shallow materialism:

> A book of hours, too, must be mine
> Just as a nobleman desires
> Let it be splendidly crafted in gold and azure
> Luxurious and elegant . . .

To judge from the books that survive, Deschamps's complaint had no impact. The
demand for richly decorated books of hours exploded at the beginning of the fifteenth
century, and Paris experienced one of its greatest flowerings as a center of manuscript
illumination. Aided by assistants and collaborators, the anonymous artist called the
Boucicaut Master, the city's finest illuminator, supplied the market generously with
books of hours. This one, created for a rich bourgeois woman named Margaret, shows
the expensive pigments the Boucicaut Master employed to dazzle his clients and the
very high level of artistic refinement he achieved.

In the page shown here, a suffrage (or prayer invoking the intercession of saints)
for All Saints is illustrated by the holy men and women robed in elegant and rich colors
of rose, burgundy, gold, orange, and several shades of blue. A stock (even dull) subject,
the artist enlivens it through the alert and engaged expression of each of the figures.
The lifetime of the Boucicaut Master (fl. 1400–1420) saw the dawn of a tradition
in Northern European painting that imparted fresh attention to the interior lives of
its subjects. This interest in characterization and human psychology has remained
an essential element in European painting since that time. TK

In illo tpe. Apprehen
dit prlatus ihesum
et flagellauit eum

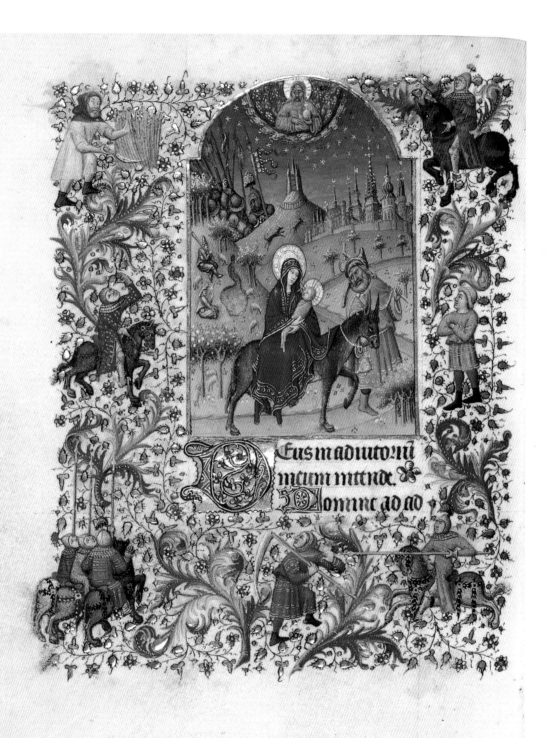

32 Book of Hours
 Probably Paris, circa 1415–1425

247 leaves, 20.1 x 15 cm
(7 15/16 x 5 7/8 in.)
Ms. 57; 94.ML.26

Plates: Spitz Master,
The Road to Calvary, fol. 31
The Flight into Egypt, fol. 103v

See pages 78–79

This manuscript was produced in the orbit of the Limbourg Brothers, who painted only a handful of manuscripts and worked primarily at the court of John, Duke of Berry (1340–1416). The books they painted for him are among the greatest of the later Middle Ages. Some of the Getty book's miniatures, including that of *The Road to Calvary* (fol. 31), are adapted from illuminations by the Limbourgs. Here Christ is shown barefoot but in a fine robe trimmed in gold thread, carrying the cross through the city gate of Jerusalem toward Calvary. A pair of soldiers pull and push him along his path. In the distance, the remorseful Judas is shown having hanged himself. To heighten the page's spiritual and contemplative character, the illuminator has added to the border angels carrying the Instruments of the Passion: a crown of thorns, a spear with a sponge, utensils for human flagellation, pliers for removing nails from the cross, and the nails themselves.

In the painting of the garments, the use of expensive materials (including burnished silver), and the tender expressions of the figures, this miniature epitomizes the refinement and elegance of court art at the beginning of the fifteenth century. When not copying, the Spitz Master shows a different side of his personality. In *The Flight into Egypt,* Joseph leads Mary on a donkey to escape the cruel Herod, King of Judea, who has decreed the death of all young children in an effort to destroy the newborn Christ Child. The illuminator shows the Holy Family journeying through a hilly, seemingly enchanted landscape. At the left, Herod's men are shown in pursuit; their enormous heads peeking over the horizon dwarf their surroundings. The exaggerated scale of the soldiers and buildings contributes to the sense of danger and enchantment in the Holy Family's escape.

The border illustrates the Miracle of the Wheat Field, another incident on their flight. When the Family passes a worker sowing wheat in the fields, the Virgin asks him to inform their pursuers that he saw the Family while sowing. The illuminator depicts the soldiers' arrival shortly thereafter, when the wheat has miraculously grown tall, so the sower's true account suggests to the soldiers that they are well behind. TK

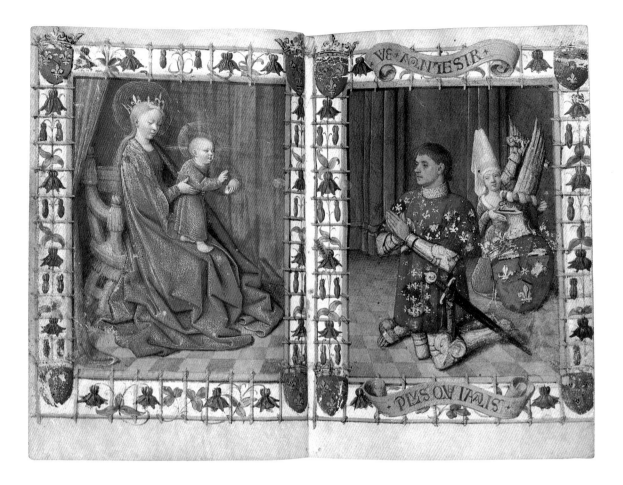

33 Hours of Simon de Varie
 Tours and perhaps Paris, 1455

97 leaves, 11.5 x 8.2 cm
(4½ x 3¼ in.)
Ms. 7; 85.ML.27

Plate: Jean Fouquet, *Simon de Varie
in Prayer Before the Virgin and Child,*
fols. 1v–2

Portraiture was one of the great achievements of fifteenth-century painting, especially in Northern Europe. The French artist Fouquet (d. 1478/81) was one of its most accomplished practitioners. In his youth he portrayed Pope Eugene IV (1431–1447), and he subsequently received many commissions from the court of the French king Charles VII (r. 1422–1461).

Among the court officials was Simon de Varie who, recently ennobled, had risen to a post in the royal treasury under Charles VII. He is shown here as a handsome youth kneeling in prayer before the Madonna and Child. While earlier books of hours had featured similar devotional portraits, what is unusual in the Varie Hours are the patron's arms, also painted by Fouquet on the backs of the two leaves. This ensemble of four illuminations, probably placed at the front of the book, offers an eloquent statement of the patron's pride in his lofty new status in society.

Although Varie was not a soldier, he wears a suit of armor and a surcoat with his personal heraldry. Behind him a female attendant supports a Varie escutcheon crowned with helmet and crest. Similar coats of arms (all now partially overpainted) and Simon's personal mottoes appear in the borders. The motto in the upper border, *Vie à mon désir* (Life according to one's desire), is an anagram of his name.

The complete Varie Hours includes forty-nine large miniatures by four artists and several dozen other vignettes and historiated initials. A later owner divided the book into three volumes. The Getty Museum owns one and the two others belong to the Royal Library in The Hague in the Netherlands. TK

34 Book of Hours
 Tours, circa 1480–1485

145 leaves, 16.3 x 11.6 cm
(6 ⁷⁄₁₆ x 4 ⁹⁄₁₆ in.)
Ms. 6; 84.ML.746

Plate: Jean Bourdichon,
The Coronation of the Virgin, fol. 72

This ceremonious, joyful miniature shows two angels crowning the Virgin Mary as Queen of Heaven. God the Father offers his blessing from heaven as he displays an orb, the symbol of his universal dominion. Below, an assembly of angels bears witness to the hallowed event. Painted by Jean Bourdichon of Tours (circa 1457–1521), official painter to four successive French kings, this manuscript contains some of his earliest known work. Bourdichon succeeded Jean Fouquet as royal painter, and his art shows the powerful impact that Fouquet's innovations exercised on French illumination in the second half of the fifteenth century.

While Bourdichon probably had not visited Italy at this early moment in his career, he learned from Fouquet principles of Italian Renaissance painting. These include the use of symmetry and geometric form to compose the miniature; for example, he arranges the angels at the feet of the Virgin in an ellipse. Bourdichon probably also learned from Fouquet to paint both spiritual and physical light. Golden rays of divine light emanate from the Virgin (against a celestial curtain of dense blue), while the same light softly models the draperies of the two angels and the faces of those below. One of the more subtle effects is the slight twist in the axis of the crowning angels, which relieves the composition's marked symmetric character and strengthens the illusion of recession.

The initials *I* (or *J*) and *K* appear four times in the border, the *I* embraced by a loop that forms the arms of the *K*. Such letters usually are the initials of a husband and wife who commissioned the book. The prominence of several prayers to Saint Catherine of Alexandria suggests that the *K* may refer to an owner named Catherine.

TK

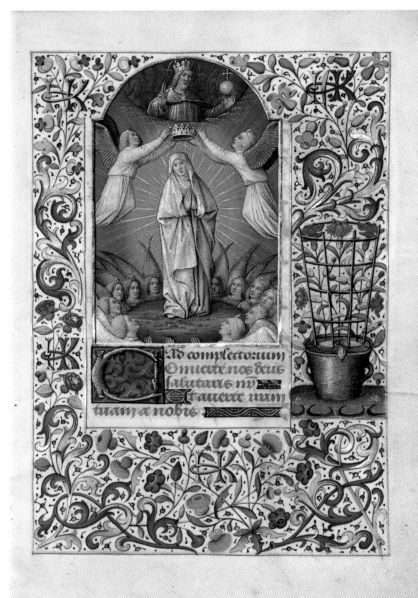

Ad complectorium
Omurte nos deus
salutaus ny
Et auerte iram
tuam a nobis

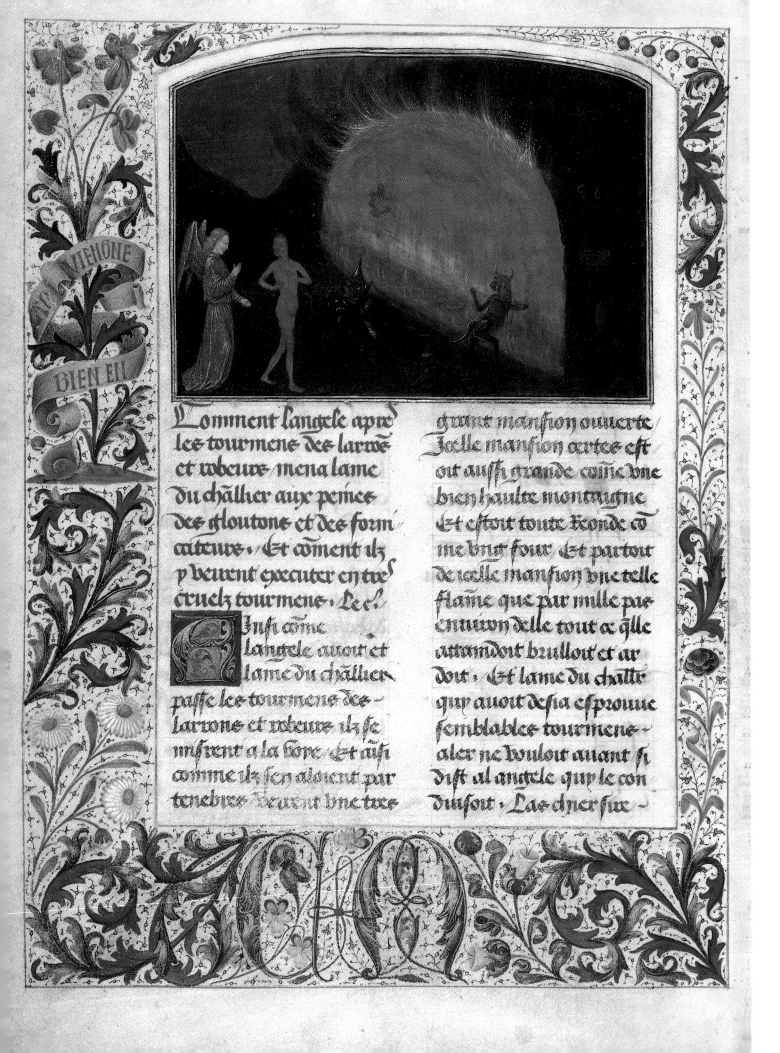

ET A VIE HORE

BIEN EN

Lomment langele apre
les tourmens des larros
et robeurs mena lame
du chaillier aux peines
des gloutons et des forni
caiturs. Et coment ilz
y beurent executer en tre
cruelz tourmens. Le cl

Insi come
langele auoit et
lame du chaillier
passe les tourmens des
larrons et robeurs ilz se
mirent a la bope. Et aufi
comme ilz fen aloient par
tenebres beurent vne tres

grant manfion ouuerte
Icelle manfion certes eft
oit auffi grande come vne
bien haulte montaigne
Et eftoit toute Reonde co
me vnß four. Et partout
de icelle manfion vne telle
flame que par mille pie
enuiron delle tout a elle
attaindoit bruilloit et ar
doit. Et lame du chaiter
quy auoit defia efprouue
femblables tourmens
aler ne bouloit auant fi
dift al angele quy le con
duifoit. Las chier fire

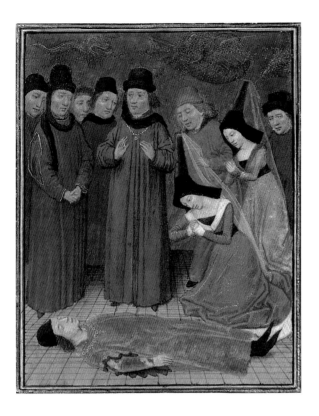

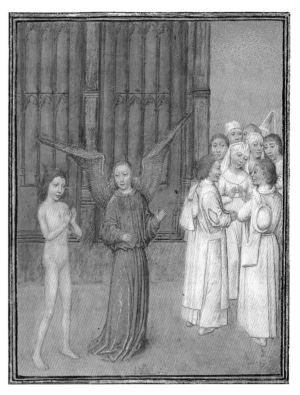

35 *Les Visions du chevalier Tondal*
Ghent and Valenciennes, 1475

45 leaves, 36.3 x 26.2 cm
(14⁵⁄₁₆ x 10⁵⁄₁₆ in.)
Ms. 30; 87.MN.141

Plates: Attributed to Simon Marmion,
The House of Phristinus, fol. 21v
Tondal Appears to Be Dead, fol. 11
The Joy of the Faithfully Married,
fol. 37

Visions of a journey through hell constitute one of the most popular medieval literary genres. Before the time of Dante, *The Visions of Tondal,* the story of a morally errant Irish knight whose soul embarks on such a journey, was the most widely disseminated. Written by Marcus, an Irish monk, in Regensburg (Germany), around 1149, its Latin text came to be translated into fifteen different languages over the next three hundred years. This French translation, dated March 1475, was undertaken for Margaret of York, the Duchess of Burgundy and consort of Charles the Bold. Their initials appear in the lower border. The duchess's copy captures in twenty scenes much of the narrative's vivid, often terrifying detail. Briefly, the story of the young and selfish Tondal unfolds as follows. While visiting a friend to collect a debt, he collapses and seems to be dead. In this state an angel leads his soul on a journey, protecting it along the route from the demons and torments of hell. Tondal's soul witnesses the terrible punishments meted out for various sins, such as the cavernous House of Phristinus where gluttons and fornicators are tormented by flames and infernal monsters. The soul then passes to purgatory in a journey toward paradise. Along the way it encounters those who have lived better lives and enjoy the prospect of redemption. At the end Tondal realizes the errors of his ways and returns to a life of Christian penitence.

Simon Marmion (circa 1420–1489), a favorite painter and illuminator of the Burgundian court, appears to have created the miniatures in this volume. Departing from his characteristic use of pastel tones (which appear, for example, in *The Joy of the Faithfully Married*), Marmion conjures up the murky darkness and flickering brightness of hell, all vaporous and fiery, along with its monstrous inhabitants. TK

36 Book of Hours
 Provence, circa 1480–1490

198 leaves, 11.5 x 8.6 cm
(4½ x 3⅜ in.)
Ms. 48; 93.ML.6

Plates: *The Visitation,* fol. 34
Georges Trubert, *Sorrowful Madonna,*
fol. 159

The main illuminator of this book is Georges Trubert (fl. circa 1469–1508), who served King René I of Anjou (1409–1480) at his court in Provence for the final decade of the ruler's life. He then remained in southern France for another ten years. Himself a poet and writer, René was also a visionary patron of the arts. The book contains several miniatures that allude to specific paintings he owned, among them an older painting or icon representing a weeping, or sorrowful, Madonna that is copied in an apparently imaginary altar-reliquary. Another artist in the book, who painted *The Visitation,* shows visual similarities to both Trubert's miniatures and those of artists active to the north in the Loire valley.

The illuminators of this book explore diverse ways to make painted objects appear palpable and three-dimensional against the flatness of the page. The border of the miniature showing the meeting of the Virgin Mary, now pregnant with Jesus, and the elderly Elizabeth, who bears the future John the Baptist in her womb, depicts birds, foliage, and music-making drolleries. It is painted in brown monochrome. This gives it the character of a wood carving in shallow relief. The leaves of this "carving" curl off the edges of the painted border onto the real page, heightening the impression of depth.

More unusual and enigmatic is the miniature of an altar-reliquary in metalwork containing the *Sorrowful Madonna.* The lustrous altar is shown with wings of gold, silver, and enamel opened up, the right wing appearing to cast a shadow on the page. The altar sits on a grassy clod of earth that is in turn supported by two bronze figurines of lions. Along with the vines of columbine emerging above the shrine, this curious devotional object also casts a shadow. A piece of parchment with the words *O Intemerata* (O Immaculate Virgin) is painted to appear tacked below the Madonna, the lower right corner of the parchment curling free of its tack. *O Intemerata* are the opening words of a prayer to the Virgin that continues when the reader turns the page. TK

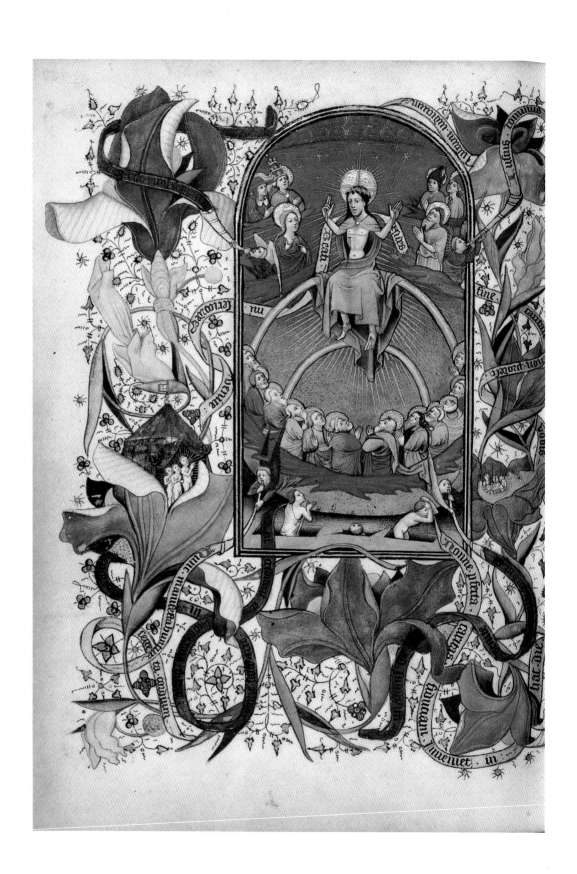

37 Book of Hours
Probably Ghent,
circa 1450–1455

286 leaves, 19.4 x 14 cm
(7 ⅝ x 5 ½ in.)
Ms. 2; 84.ML.67

Plates: Master of Guillebert de Mets,
The Last Judgment and *King David in
Prayer,* fols. 127v–128

See pages 88–89

Although a book of hours contains a common core of devotional texts, an ambitious version such as this one would have numerous supplemental texts and variations. Similarly, an illuminated book of hours could have a complex and extensive program of painted decoration, and the most far-reaching were often vehicles for artistic innovation. While borders are usually subordinate to miniatures, this manuscript reverses the relationship to a degree. The animated, monumental foliage of its borders captures the attention, and, as this two-page opening shows, the borders give unity to the whole spread.

In the borders shown here supple lilies flourish, their petals rhythmically curling and swelling, as if the flowers were opening on the pages as we turn to them. The petals pass over and under the thin frames of the miniatures, making the border's presence palpable in a way the miniatures are not. Banderoles—fluttering ribbons inscribed with text— weave paths through the borders, into and out of *The Last Judgment* on the left and *King David in Prayer* on the right. Banderoles emanate from horns blown by angels of the Last Judgment and pass under the frame at the top of the David miniature. The assembly of naked souls gathered in the opening of a lily in the left border contributes further to this integration. They are the dead resurrected to face the Last Judgment.

The two miniatures mark the beginning of the Seven Penitential Psalms, a major text in a book of hours. These psalms are meditations on human frailty and petitions to the Lord for mercy, succor, and salvation, serving to prepare the soul for the Last Judgment. The first of the seven is Psalm 6, commencing with the line: "O Lord, do not condemn me in your anger . . . " (*Domine ne in furore tuo arguas me . . .*). King David is shown penitent, his harp at his side.

The Flemish illuminator called the Master of Guillebert de Mets (fl. 1420–1450) illustrated this opening and a number of other major decorations in the book. Trained in Paris or by Parisian illuminators who worked in Flanders, he lived in or near Ghent toward the end of his life when the book was made. TK

38 Prayer Book of Charles the Bold
 Ghent and Antwerp, 1469

 159 leaves, 12.4 x 9.2 cm
 (4⅞ x 3⅝ in.)
 Ms. 37; 89.ML.35

 Plates: Lieven van Lathem, *Christ
 Appearing to Saint James the Greater,*
 fol. 22
 Text Page, fol. 30v
 Lieven van Lathem, *All Saints,* fol. 43
 Attributed to the Master of Mary of
 Burgundy, *The Deposition,* fol. 111v

 See pages 92–93

The household accounts of the Burgundian dukes record payments in 1469 to the scribe, the illuminator, and the goldsmith (who fashioned the clasps for the binding) of this elegant and costly prayer book. The duke himself, Charles the Bold (1433–1477), the son of the bibliophile Philip the Good, commissioned it. The duke paid Lieven van Lathem (circa 1430–1493) of Antwerp and Nicolas Spierinc of Ghent (fl. 1455–1499) for their illumination and writing, respectively, of this book. The original binding of this manuscript was replaced by the early sixteenth century. The work of the goldsmith Ernoul de Duvel is lost.

The diminutive volume is distinctive for the embellishment of each page, not only the illuminated pages but also those without any painted decoration. Spierinc, one of the most original of scribes, filled the borders of text pages with exuberant *cadelles,* whose lush decorative quality complements the illuminated pages. On the text page reproduced here, delicate painted drolleries further enliven the margin.

The miniatures, measuring only around three by two inches, are meticulously detailed, often with atmospheric landscapes that seem to extend for miles. Indeed, while Antwerp became famous as a center of landscape painting only in the sixteenth century, its citizen van Lathem paved the way in such miniatures as *Christ Appearing to Saint James the Greater.* The lazily winding river pulls the eye to a distant horizon. The borders are every bit as compelling as the miniatures, with their grotesques and playful figures that descend from the tradition of marginal decoration in Gothic manuscripts. Among the men and monsters gamboling in the dense foliage of the monochrome border of the same page, a lion has pinned a nervous soldier to the ground.

Although van Lathem painted most of the book's thirty-nine original miniatures, several collaborators enabled him to complete the illumination. The most gifted was the painter of the moving *Deposition,* which anticipates in its depth of feeling and the nuanced rendering of the fragile corpse of the dead Christ the mature art of the Master of Mary of Burgundy, the doyen of Burgundian illuminators (see no. 42). It is perhaps one of his earliest works. Here the border vignette of Adam and Eve mourning the death of Abel offers an Old Testament prefiguration of the mourning over the body of Christ as he is taken down from the cross. TK

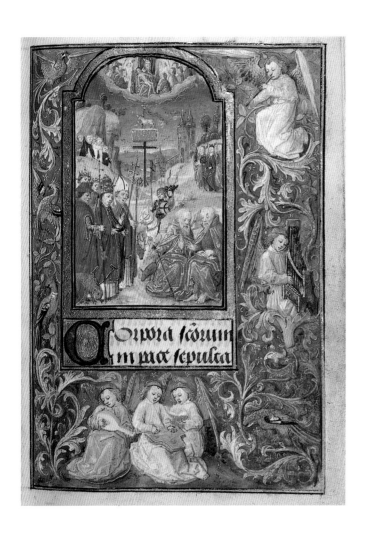

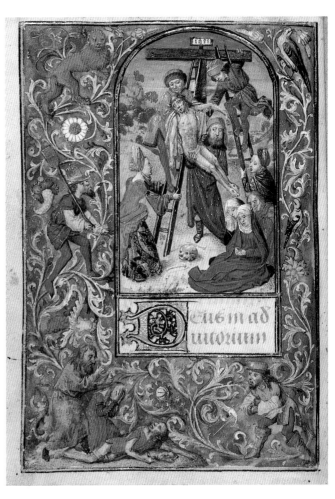

39 Fifteen Leaves from David Aubert,
Histoire de Charles Martel
Brussels and Bruges,
1463–1465 and 1467–1472

22.6 x 18.4 cm (8¹⁵⁄₁₆ x 7 ¼ in.)
Ms. Ludwig XIII 6; 83.MP.149

Plate: Loyset Liédet, *Gerard and
Bertha Find Food and Sustenance
at a Hermitage,* leaf 5

Philip the Good, Duke of Burgundy (1419–1467), not only expanded dramatically the size of the duchy of Burgundy but also built one of the great libraries of the fifteenth century. It contained more than seven hundred volumes. His vast patronage fostered the most important era of manuscript illumination in Flanders, one that continued long after his death. This miniature and fourteen others at the Getty were once part of the *Histoire de Charles Martel* (History of Charles Martel) that was written for him in four volumes—for a total of two thousand leaves or four thousand pages—by court scribe David Aubert over a period of several years (1463–1465). Philip traced his ancestry to Martel (r. 714–741), the grandfather of Charlemagne, an outstanding military leader and the ruler of the Frankish kingdom (which encompassed modern France and Germany). Late medieval knights undoubtedly enjoyed reading the adventures of such ancient heroes, and Philip would have drawn inspiration from his exploits.

Several years after Philip's death, the illumination of this extravagant undertaking had barely begun. In 1468 ducal accounts show payments to one Pol Fruit of Bruges for painting the initials in the third volume. A year or so later Philip's son and heir, Duke Charles the Bold, hired Loyset Liédet to paint the book's 123 miniatures. During the 1460s and 1470s, the prolific Liédet worked in Hesdin in northern France and in Bruges. He received payment for miniatures in this book in 1472. In total the manuscript took a decade to produce.

The illustration shown here represents Gerard de Roussillon, the great hero of the Burgundians and a rival of Charles Martel, with Bertha, his wife. After being robbed of their horses, they are offered food and find drink at a spring.

The four volumes of the book, still preserving 101 of the original miniatures, belong to the Bibliothèque Royale in Brussels, which acquired the core of Philip the Good's library. TK

courzouchiee que plus elle nen pouoit / Et moult souuet
regrettoit sa suer / et tous les iours ne attendoit aultre
chose forz que elle retournast vers elle a reffuge / mais
a tant sen taist vng petit listoire / Et retourne a parler
du mal fortune prince monseigneur gerard de roucillon

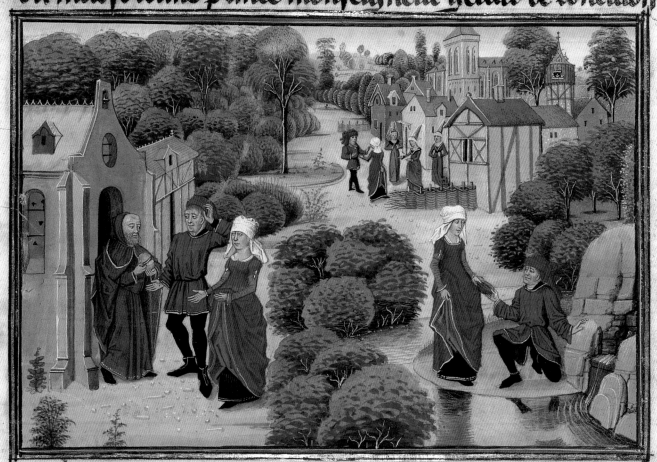

Comment le noble prince gerard de roucillon deuint
Charbonnier par fine contrainte de pourete et misere.

Ancienne histoire racompte que quant
le noble prince gerard de roucillon se fut
party des marchans de france lesquelz
luy auoient dit nouuelles de la mort du
roy othon de hongrie / et des francois auy tantost-

40 Quintus Curtius Rufus,
Livre des fais d'Alexandre le grant
Lille and Bruges,
circa 1468–1475

237 leaves, 43.2 x 33 cm (17 x 13 in.)
Ms. Ludwig XV 8; 83.MR.178

Plate: Attributed to the Master of the
*Jardin de vertueuse consolation,
Alexander and the Niece of
Artaxerxes III,* fol. 123

Alexander the Great (356–323 B.C.), King of Macedonia, conquered much of the ancient world. He gained vast territories extending from the eastern Mediterranean to northern India. His fame endured throughout the Middle Ages and his name still evokes wonder today. The emergence of humanism in Northern Europe during the second half of the fifteenth century fostered the desire for a reliable account of his exploits, one no longer encumbered with the stuff of legend and romance that had accrued during the Middle Ages. Vasco da Lucena, a Portuguese diplomat and humanist at the Burgundian court, chose the text of the ancient Roman historian Quintus Curtius Rufus, who appears to have lived in the first century, as the most reliable of the ancient accounts. Vasco endeavored to translate it into French while replacing portions that were lost. His effort, dedicated to Charles the Bold, Duke of Burgundy, enjoyed popularity at the court and throughout Flanders and France. The Getty copy was probably made for a nobleman in the circle of the duke.

In the miniature illustrated here the niece of the Persian king Artaxerxes III (r. 358–338 B.C.) is shown kneeling before Alexander. The conqueror had noticed her among his Persian prisoners. Because she is a member of a royal family, he decides to free her and return her belongings. Vasco detailed such incidents to provide a balanced picture of his subject's character; elsewhere in the text he shows us Alexander's cruelty, vanity, and other frailties. The book's anonymous painter also illuminated other large-format volumes for Burgundian noblemen. His art shows affinities with that of the Antwerp illuminator Lieven van Lathem (no. 38). Jean du Quesne, who transcribed this copy of Vasco's text, was himself the translator of other humanist texts.

Large histories such as these were read aloud to their owners from a lectern. Alexander's exploits must have appealed especially to the knights of the Burgundian court, while the convention of depicting ancient personalities in the contemporary dress of the court gave the stories particular immediacy. The fourteen miniatures of the Getty *Alexander* are colorful and filled with action. They show battles and conquests, assassinations and court intrigue. TK

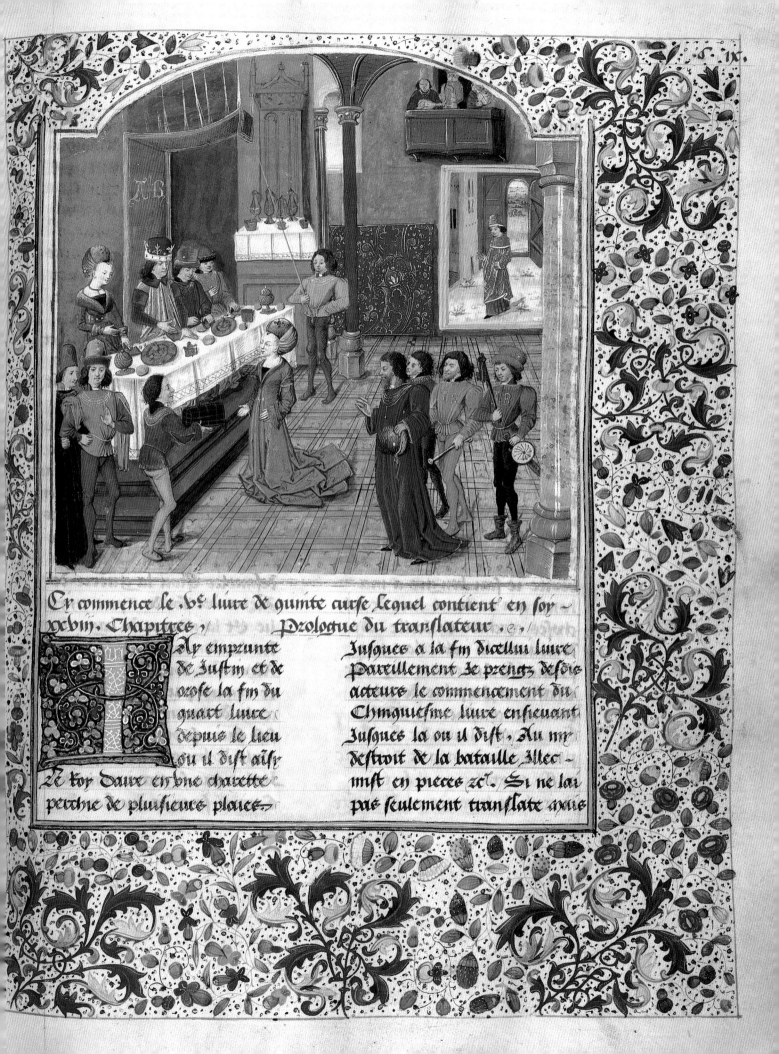

Cy commence le .vͤ. liure de quinte curse lequel contient en soy
xcviii. Chapitres · Prologue du translateur ·e·

Iay emprunte de Justin et de orose la fin du quart liure depuis le lieu ou il dist ainsy Le roy daure en une charette perthe de plusieurs plaies

Jusques a la fin dicellui liure Pareillement Je prens desdis acteurs le commencement du Cinquiesme liure ensieuant Jusques la ou il dist. Au my destroit de la bataille Illec mist en pieces zc. Si ne lai pas seulement translate ayns

41 Miniature from Valerius Maximus,
 *Faits et dits mémorables des
 romains*
 Bruges, circa 1475–1480

 17.5 x 19.4 cm (6¹⁵⁄₁₆ x 7⅞ in.)
 Ms. 43; 91.MS.81

 Plate: Master of the Dresden
 Prayer Book, *The Temperate
 and the Intemperate*

The Memorable Deeds and Sayings of the Romans is a compilation of stories about ancient customs and heroes. Written in the first century A.D. by Valerius Maximus (fl. circa A.D. 20), it continued to be read during the Middle Ages. Loosely organized by moral and philosophical categories (temperance, charity, cruelty, etc.), Valerius Maximus, as the book is often called, served as a textbook of rhetorical exercises. Its popularity grew in the later Middle Ages due to vernacular translations, such as the French one commissioned by Charles V of France (r. 1364–1380). This cutting derives from a folio-size copy of the French translation made for Jan Crabbe, the Abbot of the Cistercian Abbey at Duinen, south of Bruges.

This large miniature appeared at the beginning of book 2. It shows Valerius instructing the emperor Tiberius (to whom he dedicated the text) on the value of temperance. In a spacious dining room, the upper classes shown at the back behave decorously—displaying temperance—while in the foreground the antics of lower-class characters illustrate the antithesis. In the hands of the prolific Master of the Dresden Prayer Book, a witty anonymous illuminator from Bruges, the appropriate behavior seems staid, while the bad example amuses us. Over the next two centuries drunkenness and other foibles of the middle and lower classes would become beloved and even trademark subjects of Flemish painters. They were preceded by Flemish illuminators, who left us a trove of miniatures of social customs and behavior that inform us about the values of the time. TK

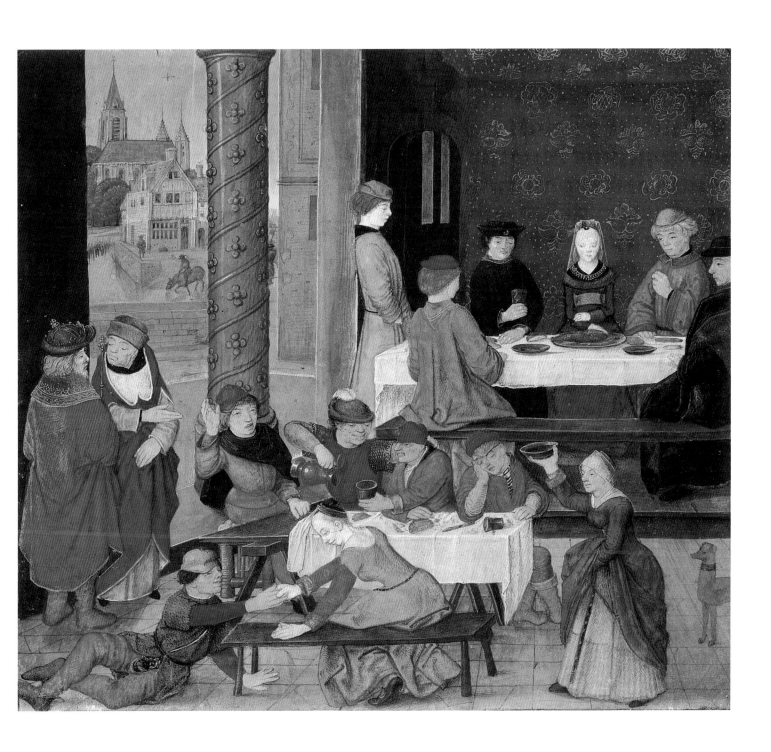

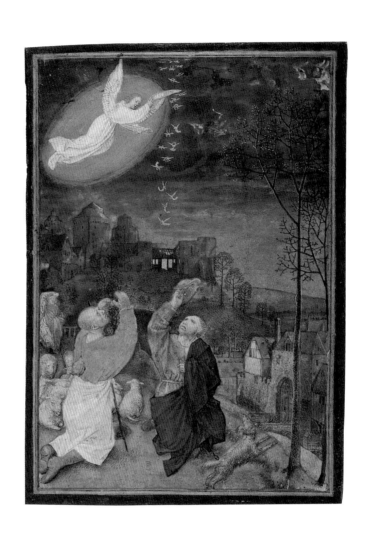

42 Miniature from a Book of Hours
Probably Ghent, before 1483

12.5 x 9 cm (4⅞ x 3½ in.)
Ms. 60; 95.ML.53

Plate: Attributed to the Master of
Mary of Burgundy, *The Annunciation
to the Shepherds*

One of the geniuses of the Golden Age of Flemish painting in the fifteenth century is
the enigmatic manuscript illuminator named the Master of Mary of Burgundy. He
takes his name from Mary, Duchess of Burgundy (1457–1482), among the most
powerful of his presumed patrons. He practiced his art only from around 1470 to
1490, and he worked in the region of Ghent in Flanders, where he was an associate of
Hugo van der Goes (circa 1436–1482), whose paintings strongly influenced him. The
Master of Mary of Burgundy was the only Flemish artist of the time whose work rivaled
van der Goes's works in their emotional power and their sympathy for common people.
In this miniature the shepherds have the coarse and rugged features of peasants in
paintings by van der Goes. Their faces are drawn with a richness of modeling and
precision of contour that find no equal in Flemish manuscript illumination. The artist's
achievement is all the more remarkable when one considers that he customarily painted
in this very small format.

The nocturnal scene with rolling hills is lit only by the glow of the graceful angel
high in the sky, by a diminutive ballet of gilded angels gliding down toward the
manger, and by the light within the stable itself. Nocturnal subjects strongly attracted
Flemish, Dutch, and French painters in the last quarter of the fifteenth century.

The miniature probably comes from an elaborate illuminated book of hours that is
now in the Houghton Library at Harvard University, Cambridge, Massachusetts. That
book's decoration represented a collaboration with Simon Marmion (see no. 35) and
the Master of the Dresden Prayer Book (see no. 41), two of the other leading artists of
the day. It was possibly made for a Spanish patron. Unfortunately, many of the book's
other full-page miniatures are lost. TK

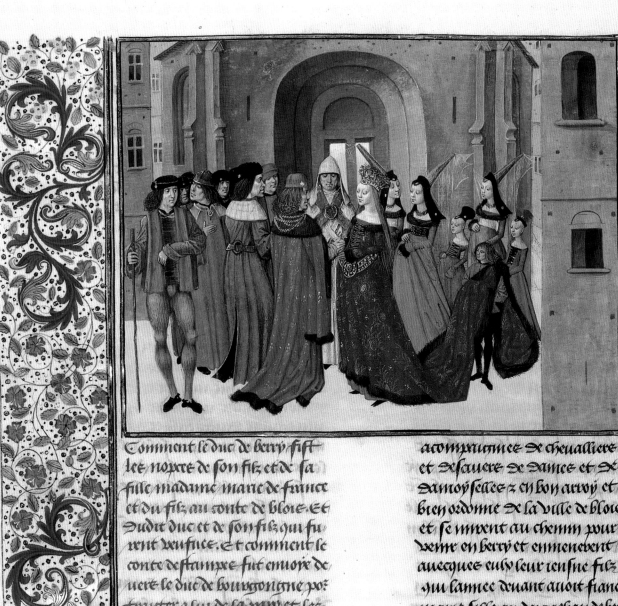

Comment le duc de berry fist
les nopce de son filz et de sa
fille madame marie de france
et du filz au conte de blois. Et
dudit duc et de son filz qui fu-
rent veufues. Et comment le
conte destampes fut enuoye de
uers le duc de bourgongne por
traicter a fin de la paix et le re-
sponce que le duc lui fist.
Chappe. xxoy. v. c.

C
N lan de lin
carnation nre
seigneur mil
t troiscens iiij.xx
et xix ou mois
daoust se de
party le conte guy de blois z la
contesse marie sa femme bien

acompaignee de cheualiere
et de scauere de dames et de
damoyselle z en bon arroy et
bien ordonne de la ville de bloie
et se mirent au chemin pour
venir en berry et emmenerent
auecques eulx leur ienne filz
qui lannee deuant auoit fiancee
marie fille au duc iehan de berry
et estoit lintencion au conte de
blois et a la contesse que eulx
venuz a bourges en berry leur
filz procederoit auant ou mari
age z aussi estoit telle lenten
cion du duc de berry et a la du
chesse sa femme. Si que qnt
toutes ces parties furent venues
les vnes deuant les autres le
mariage de ces deux ienfnes

43 Jean Froissart, *Chroniques,*
 Book 3
 Bruges, circa 1480

366 leaves, 48.2 x 35 cm
(19 x 13¾ in.)
Ms. Ludwig XIII 7; 83.MP.150

Plate: Master of the White Inscriptions,
*The Marriage of Louis de Blois and
Marie de France,* fol. 288v

The monumental *Chronicle* written by Jean Froissart (1337–circa 1410), covering the period from around 1322 to 1410, is the most famous historical record of the fourteenth century. It recounts the major political and military events of the time, focusing on the rivalry between England and France. The *Chronicle* is a basic resource for the study of the Hundred Years' War (circa 1337–1453), the ongoing conflict between these kingdoms. Froissart also describes the affairs of other realms, though largely as they relate to the complex network of overlapping and shifting alliances around the protagonists. The Getty manuscript contains only book 3 (of four), which describes "the recent wars in France, England, Spain, Portugal, Naples, and Rome." Its 730 pages cover the period from 1385 to 1389, an indication of the level of detail Froissart sought to impart. He conducted plenty of research. For book 3 he traveled to the territories ruled by the Count of Foix in southwestern France to gather information on events in the region and on the Iberian peninsula.

The Getty volume shows the lasting esteem that the *Chronicle* enjoyed. It was produced about seventy years after the author's death, when a number of other copies of his *Chronicle* were transcribed and illuminated. This one was painted in Flanders, perhaps in Bruges. The choice of subjects for the sixty-four miniatures strongly emphasizes events involving the English, evidence perhaps that the book was produced for the insular market. The English and the Burgundians, who ruled from various towns in Flanders and northern France, were allies during this period, and the English exhibited a strong taste for all things Burgundian, including Flemish paintings, tapestries, and illuminated manuscripts. Margaret of York, Duchess of Burgundy (1446–1477), helped her brother, the English king Edward IV (r. 1461–1483) to obtain various books, tapestries, and other treasures from Flemish artists. Circumstantial evidence suggests that Edward himself may have purchased this book for his library.

The miniature reproduced here illustrates the marriage of Louis de Blois and Marie de France, the daughter of the Duke of Berry, at the portal of the Cathedral of Saint Étienne in Beauvais in 1386. Louis was the son of Froissart's patron Guy, Count of Blois, who commissioned book 3 of the *Chronicle*. Consistent with the artistic tradition of the time, the wedding couple and their party wear the extravagant fashions of the Burgundian court in the illuminator's day—not the costumes of the fourteenth century. TK

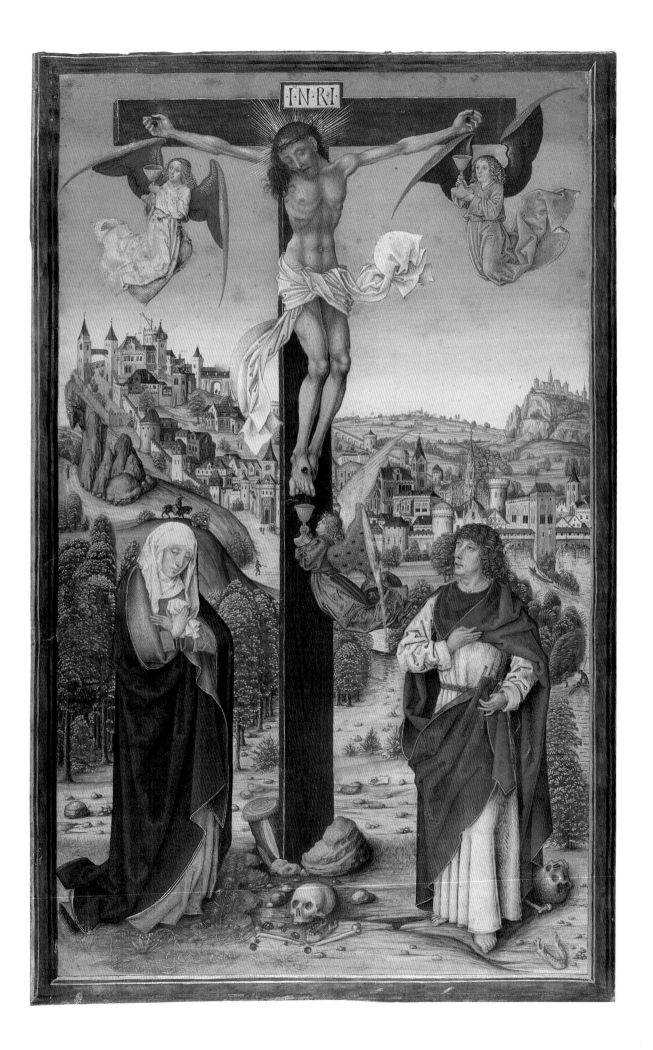

44 Miniature, Perhaps from a
Manuscript
Probably Franconia (Germany),
last quarter of the fifteenth
century

38.8 x 24.3 cm (15�5/16 x 9⁹/16 in.)
Ms. 52; 93.MS.37

Plate: *The Crucifixion*

This monumental *Crucifixion* shows the deceased Christ on the cross on the mount of Calvary. Three angels—two at his wrists, another at his feet—capture his blood in chalices. Below, the sorrowful mother of Jesus lowers her head, her eyes closed and her hands crossed over her bosom. Opposite her, John the Evangelist stands quietly, his right arm reaching over his heart. The ritual symbolism in this representation of the Crucifixion was popular in Germany around 1500. The capturing of the blood of Christ in the chalice of Holy Communion refers to the transubstantiation of bread and wine in the Eucharist, the sacrament celebrated in the mass. In receiving Communion worshipers partake of bread and wine that has been consecrated by the priest at the altar. The body and blood of Christ are understood to be present in the Eucharistic elements.

The miniature's background shows Jerusalem in the guise of a prosperous German town of the late fifteenth century. Although not identified securely, its location on a sloping bluff and with a river passing through it may be inspired by the topography of the bustling metropolis of Nuremberg in Franconia. The skull and bones at the foot of the cross allude to "Golgotha," the Hebrew name for Calvary, meaning "place of the skull." The skull may also refer to Adam, who was thought to be buried there.

A full-page Crucifixion miniature is the most important illustration in a missal (or mass book) and often the only one. It is located at the canon of the mass, the Communion prayer. A number of missals printed in Germany at this time have woodcut illustrations for the canon with similar allusions to the celebration of the Eucharist. In these representations, as here, the cross in the shape of a T derives from a long-standing tradition in which it also served as the first letter of the canon, which begins *Te igitur clementissime pater* (You, therefore, most merciful father). This miniature may thus have been painted for inclusion in such a missal. If so, the book would have been exceptionally large and impressive. TK

45 Historiated Initial from a
Gradual
Probably the Veneto, possibly
Verona, circa 1440–1450

14.2 x 9 cm (5⁹⁄₁₆ x 3½ in.)
Ms. 41; 91.MS.5

Plate: Attributed to Antonio Pisano,
called Pisanello, and the Master of
Antiphonal Q of San Giorgio Maggiore,
Initial *S* with *The Conversion of Saint
Paul*

Saint Paul, one of the most significant figures in the formation of the Catholic Church, endeavored to spread the Gospel beyond the Jews to the world at large. This historiated initial *S* (now closely trimmed) illustrated the mass for the feast of the Conversion of Saint Paul (January 25) in a gradual, a book containing the chants sung during mass. While journeying to Damascus, Saul, a Jew, experiences a light from heaven that engulfs him and his companions (Acts 9:1–9 and 26:12–18). He falls to the ground and hears the voice of Jesus calling him to become a Christian evangelist. Saul converts, changes his name to Paul, and preaches the new faith.

In this initial, Saul, dressed in a soldier's helmet and armor, tumbles to earth, his horse collapsing beneath him. Unexpected in this otherwise characteristic representation of Saul's conversion is his unassuming presence, his face barely visible beneath the helmet. The illuminator focuses instead on another soldier, seated erect on a more elaborately liveried steed in the top half of the initial. His tall, fancy *cappuccio* (hat) and the *giornea* (tunic) trimmed in green, white, and red—the colors of both the Gonzaga and Este families—suggest that he is the leader of this band of Italian soldiers. The noble and contemporary costume and the vivid profile suggest that he is not a biblical figure at all, but a youthful scion of one of these ducal families. He may have been the book's patron, commissioning the gradual for his family's use or for an ecclesiastical foundation under his protection.

Both the Gonzaga of Mantua and the Este of Ferrara were patrons of Pisanello (circa 1399–1455). Medalist, fresco painter, painter on panel, portraitist, history painter, and possibly a manuscript illuminator too, this versatile artist moved among the courts of northern Italy, Rome, and Naples. Although not all scholars consider this initial to be painted by him, Pisanello's originality and descriptive powers are evident here in the expressive use of silver to convey the luster of armor, the splendor of the central figure's silhouette including his delicate facial features, and the powerful rendering of Paul's horse. Pisanello's depiction of horses, with their muscular haunches, are among the more memorable ones in European art.

The initial's landscape was painted by an anonymous artist who worked in Verona.

TK

46 Miniature from a Devotional
or Liturgical Manuscript
Possibly Mantua,
circa 1460–1470

20.1 x 12.9 cm (7¹⁵⁄₁₆ x 5¹⁄₁₆ in.)
Ms. 55; 94.MS.13

Plate: Girolamo da Cremona, *Pentecost*

Italian artists of the fifteenth century applied mathematical principles in designing a painting. These Renaissance rules of composition—frequently adapted and rethought— would have an impact on European painting continuously down to our own day. In this miniature of Pentecost, the descent of the Holy Spirit upon the apostles, nearly all the elements are arranged symmetrically around an invisible central axis. The solemn, columnar figure of the Virgin Mary along with the Holy Spirit in the form of a radiant descending dove indicate this axis. Equidistant from the axis appear the windows, the portals in the flanking walls, the pair of candlesticks on the mantel, and the apostles themselves. The two groups of apostles are organized in a mirror image of one another, a back row of three, a middle one of two, and in the foreground one each. The kneeling figures open around the Virgin like a pair of wings welcoming us. We look over the shoulders of the foremost apostles to participate.

The artist avoids the monotony of strict symmetry by varying details, such as the colors of the apostles' robes, the men's gestures, and the arrangement of books around the candles, and by showing an open window with a view opposite a closed one. The geometric clarity of this design, the Virgin's imposing height, and the tall proportions of the room give this scene a monumental quality, even though the miniature itself measures only eight inches from top to bottom.

The illuminator is Girolamo da Cremona (fl. 1458–1483), a protégé of the great painter Andrea Mantegna (circa 1431–1506). Girolamo moved among the powerful courts of Northern Italy. He illuminated books in Ferrara, Mantua, Siena, and Venice. Besides the thoughtful composition, another pleasure of Girolamo's art is his ability to describe the different textures of materials, from the stone window frames and the window's bull's-eye glass to the dull red bricks of the walls and the dyed leather bookbindings.

The *Pentecost* was made for a liturgical book or a book of private devotion. No other part of the manuscript has come to light. TK

47 Gualenghi-d'Este Hours
Ferrara, circa 1469

211 leaves, 10.8 x 7.9 cm
(4 ¼ x 3 ⅛ in.)
Ms. Ludwig IX 13; 83.ML.109

Plates: Taddeo Crivelli,
Saint Gregory the Great, fol. 172v
Saint Catherine, fol. 187v
*Saint Bellinus Receiving the Gualenghi
Family at the Altar,* fol. 199v
Saint Anthony Abbot, fol. 204v

Devotion to the saints was one of the most popular aspects of Christian piety throughout the Middle Ages and Renaissance. Saints served as intermediaries between heaven and earth and performed miracles of faith and healing for the devoted. They were petitioned by the faithful, who viewed them as special advocates before God. The virtuous lives and deeds of these holy men and women were also looked to by ordinary people as examples to be followed in their own lives. In the visual arts the cult of saints was expressed in the reliquaries and churches built to house their earthly remains, in the illustrated books devoted to their legends (see no. 23), and in their numerous representations in sculpture and painting. Devotion to saints was also an integral part of many books of hours, which contained short prayers to the saints, often illustrated, in the section of the book known as suffrages.

In this book of hours, created for Andrea Gualengo (d. 1480) and his wife, Orsina d'Este, the majority of the figural decoration is devoted to the suffrages. Andrea came from a family of high-ranking courtiers at the Este court in Ferrara and himself held important advisory and ambassadorial posts during the reigns of Borso d'Este

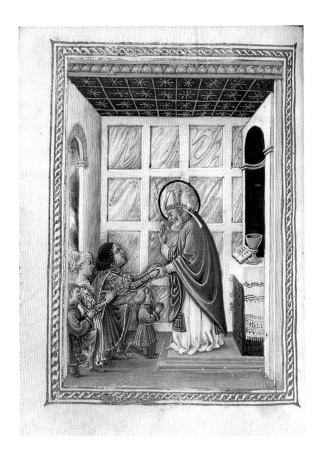

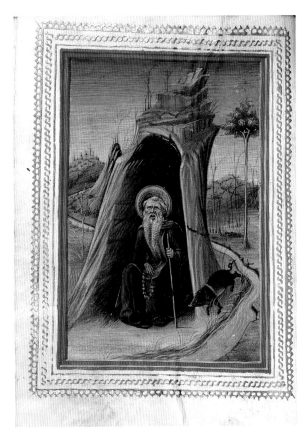

(r. 1450–1471) and Ercole d'Este (r. 1471–1505). The Gualenghi family is depicted in the miniature accompanying the prayer to Saint Bellinus (fol. 199v), a twelfth-century bishop of Padua who must have held a special importance for the patron. The painting illustrates explicitly the relationship among mortal, saint, and God and underlines the intermediary role of the saint. The family kneels in prayer before the altar at which Saint Bellinus is celebrating mass. With one hand the saint clasps the outstretched arms of Andrea Gualengo while he gestures toward heaven with the other.

Saint Gregory the Great (circa 540–604) is also shown in an act of devotion directed toward heaven (fol. 172v). Seated before an altar, he looks up toward the divine light entering the niche overhead and opens his mouth as if in song. As in many other paintings in this book, Taddeo Crivelli infused the subject matter of divine presence entering into the world with a sense of spiritual rapture; the putto tangled in a scroll, the twisting blue banderole, and the sharp shimmering rays of gold in the border as well as the energetic lines of the marble behind the saint's head endow the painting with a heightened emotional pitch. KB

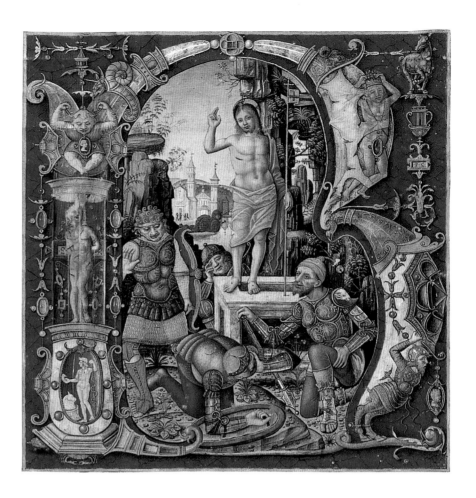

48 Gradual
Rome, late fifteenth or early
sixteenth century

188 leaves, 64.1 x 43.5 cm
(25⁵⁄₁₆ x 17⅛ in.)
Ms. Ludwig VI 3; 83.MH.86

Plate: Antonio da Monza,
Initial *R* with *The Resurrection,* fol. 16

Toward the end of the fifteenth century, artists started exploring the newly discovered Golden House of Nero (an ancient imperial villa in the city of Rome) in order to study the walls of its rooms, which were covered with painted and stucco ornament. Visitors to the site were captivated by the fantastic creatures, candelabra, garlands, and delicate architectural elements represented on the interior walls. The Renaissance mania for all things of the classical world meant that the motifs, known as grotesques because of their association with the underground "grottoes" of the unexcavated house, were rapidly incorporated into the ornamental vocabulary of High Renaissance painting.

Fra Antonio da Monza, the illuminator of this large gradual made for the Franciscan Church of Santa Maria in Aracoeli in Rome, was one of the many Italian Renaissance artists who were profoundly influenced by the remains of classical art. The painted embellishment of the Getty's gradual not only draws on the sort of motifs found on the walls of the Golden House of Nero but also includes representations of antique cameos and other gems.

The opening page of the mass for Easter Sunday (fol. 16) is the most elaborate in the book, and its illumination is a stunning accomplishment of decoration *all'antica* (in the antique manner). The Christian subjects are the Resurrection (in the initial *R*), the Martyrdom of Saint Sebastian (seen through a glass cylinder that forms part of the letter *R*), the Annunciation (in a pair of roundels in the border on the sides of the page), and a bust of Christ (in the lower border). This Christian imagery shares the page with a wealth of classically inspired hybrid creatures and putti, all presented within a composition reminiscent of the schemes on the walls of Roman imperial houses. ECT

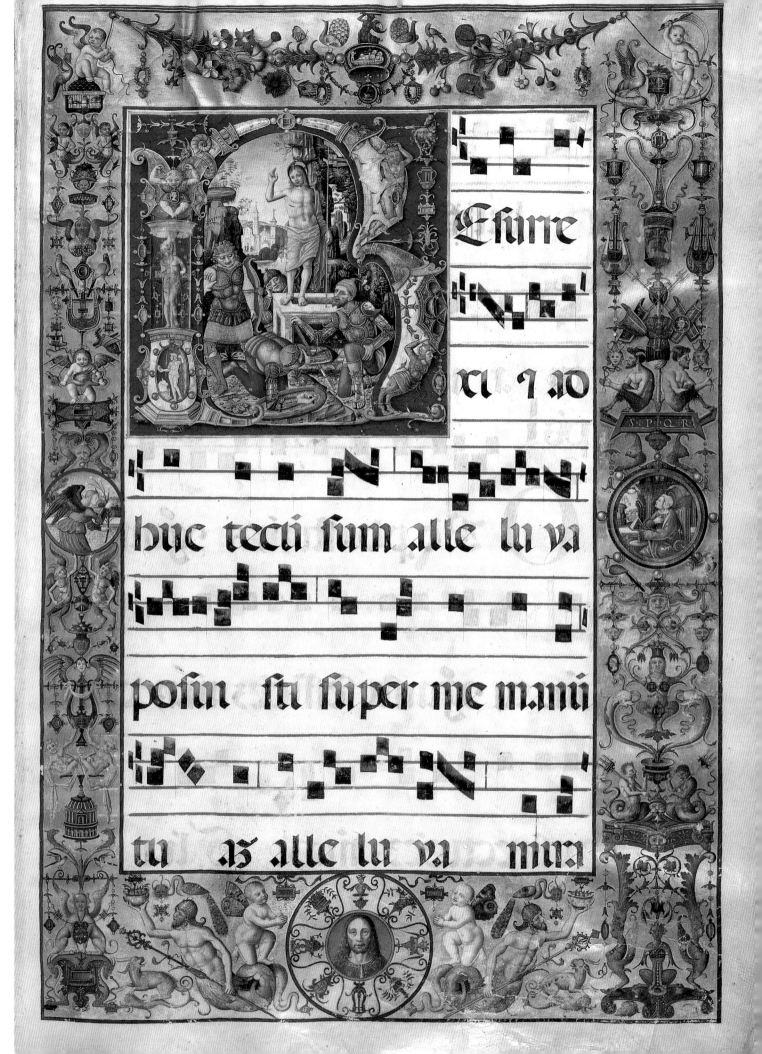

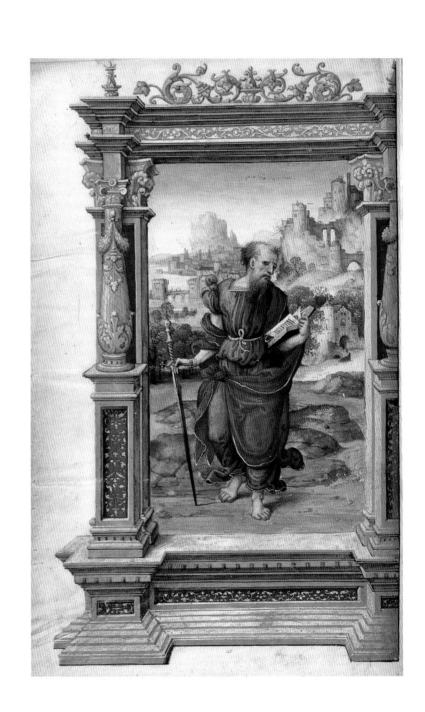

INCIPIT ARGVMENTVM IN EPISTOLA
BEATI PAVLI AD RO
MANOS

R OMANI funt partis Italiæ. Hi
præuentifunt a falfis Apoftolis
et fub nomine domini noftri Ie
fu Chrifti in legem et prophetas
erant inducti. Hos reuocat Apoftolus ad verã
et euangelicam fidem : fcribens eis a Corintho

INCIPIT EPISTOLA BEATI PAVLI
APOSTOLI AD ROM
MANOS

P AVLVS feruus Iefu Chrifti
vocatus Apoftolus : fegregatus
in euangelium dei quod ante
promiferat per prophetas fu
os in fcripturis fanctis de fi
lio fuo. qui factus eft ei ex femine Dauid fecun
dum carnem . Qui prædeftinatus eft filius dei
in virtute fecundum fpiritum fanctificationis
ex refurrectione mortuorum Iefu Chrifti domi
ni noftri : per quem accepimus gratiam et Apo

49 Getty Epistles
 France, circa 1520–1530

 112 leaves, 16.4 x 10.3 cm
 (6½ x 4 1/16 in.)
 Ms. Ludwig I 15; 83.MA.64

 Plates: Master of the Getty Epistles,
 Saint Paul and Text Page, fols. 5v–6

 See pages 114–115

In both content and appearance this French book is a product of the Renaissance. It offers distinctive evidence of the diverse paths by which the rebirth of learning and the visual arts that began in Italy spread throughout Europe in the sixteenth century. Toward the beginning of the century scholars took up the study of Saint Paul's letters with renewed fervor. The humanist Erasmus of Rotterdam (circa 1466–1536) and other Church reformers were attracted by his teachings to the Romans. Their interpretation of the epistles as sanctioning justification through faith rather than deeds became a topic of theological debate.

The Master of the Getty Epistles was the leading artist in a popular workshop of the Loire valley that specialized in decorating devotional books during the 1520s. The sources of his art are complex. The figure of Saint Paul, muscular and swathed in heavy robes, ultimately takes its inspiration from the art of Michelangelo, but the artist, who was trained in Flanders, probably knew the art of the Italian master only through his Northern European followers. The meandering, hilly, and spacious setting reflects the nascent art of landscape painting that made the Flemish school in Antwerp celebrated at this time.

The border of fruit and flowers is also Flemish in inspiration, while the elaborate architectural border framing the miniature shows many elements from ancient Roman architecture recently revived in Italy. Also pointedly Italianate is the crisp and easily readable humanist script, itself a revival of medieval Carolingian letter forms that humanists believed to be ancient. Moreover, the separation of the rubrics (or headings) from the text, their symmetrical design, and the spaciousness in arranging the components reflect the new attitude toward page design found in Italian printing. In this two-page opening, the arrangement of the text has received as careful attention as the composition of the miniature. Thus diverse threads of the artistic, intellectual, and technological ferment of the Renaissance are interwoven on the pages of the Getty Epistles. TK

50 Spinola Hours
Ghent or Mechelen,
circa 1510–1520

312 leaves, 23.2 x 16.6 cm
(9⅛ x 6⁹⁄₁₆ in.)
Ms. Ludwig IX 18; 83.ML.114

Plates: Gerard Horenbout
(The Master of James IV of Scotland),
The Holy Trinity Enthroned and
Abraham and the Three Angels,
fols. 10v–11

See pages 118–119

The Spinola Hours (named for the Genoese noble family that once owned the book) is one of the most sophisticated Flemish manuscripts of the sixteenth century. It contains eighty-eight miniatures within six hundred pages. Every page that lacks a miniature has fully decorated borders, most painted illusionistically with flowers and insects. For all the spiritual gravity of their subject matter, the miniatures in this book are often playful, teasing the viewer to believe in their painted illusions.

Miniatures in books of hours generally appear above the opening words (or incipit) of the book's main devotions. In this manuscript the miniature, illustrating a set of devotions called the Hours of the Holy Trinity, appears not only above the text but beside and below it, filling those regions of the page where a painted border traditionally appeared. The Trinity is shown as three persons in one: God the Father, Jesus Christ, and the Holy Spirit. They hold an orb, the symbol for universal dominion, while the central figure raises his hand in blessing. To further challenge our perceptions, the incipit appears not only on the genuine parchment but also on a slip of parchment painted on the miniature. This piece of parchment is "pinned" to the flat surface of the otherwise spacious miniature so that one painted illusion reveals the other for what it is.

Each major opening in the book has two miniatures. On the page facing *The Holy Trinity Enthroned* appears the Old Testament story of the elderly Abraham offering hospitality to three angels. They have come to announce that Sarah, his old and barren wife, will bear a child (Genesis 18:1–19). In the foreground Abraham bows down to the angels when they first appear. Above, as Abraham offers them food, Sarah peeks out of the opening in the tent behind them, smiling at the surprising tidings. The three angels were viewed as an Old Testament prefiguration of the Holy Trinity.

Gerard Horenbout was the finest Flemish illuminator of the first two decades of the sixteenth century and court painter to Margaret of Austria, Regent of the Netherlands. Circumstantial evidence suggests that this ambitious and expensive book, which engaged the talents of a host of prominent illuminators, including Simon Bening (see nos. 51–52), may have been made for her. TK

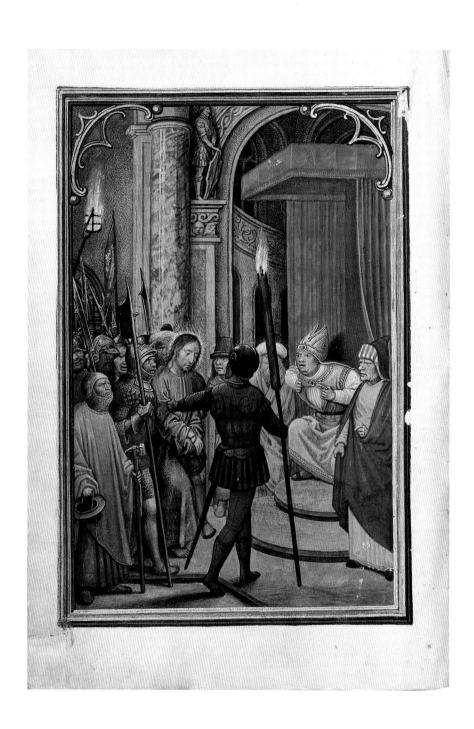

51 Prayer Book of Cardinal Albrecht
of Brandenburg
Bruges, circa 1525–1530

337 leaves, 16.8 x 11.5 cm
(6⅝ x 4½ in.)
Ms. Ludwig IX 19; 83.ML.115

Plate: Simon Bening,
Christ Before Caiaphas, fol. 128v

The advent of the printed book, which was introduced in Europe in the mid-fifteenth century, did not make hand-written books obsolete for many generations. Indeed, the text of this manuscript, a series of prayers relating to the Passion of Christ, is copied from a book printed in Augsburg in 1521. Cardinal Albrecht of Brandenburg, Elector and Archbishop of Mainz, wanted a hand-written copy of the printed book on vellum, illustrated with woodcuts. He then hired the illuminator Simon Bening to supply a series of forty-two full-page miniatures (along with historiated borders and other decorations). Albrecht probably preferred not only Bening's artistry to that of the woodcut illustrator, but the luxuriousness and durability of parchment to paper and the saturated colors of illumination to the black-and-white of the woodcut. Competition with the printed illustration probably spurred the unrivaled period of creativity and originality that characterizes Flemish illumination after 1450.

Here the combination of the verisimilitude of Bening's art with a great story told in many scenes results in an uncommonly vivid and moving narration. The artist exploits the drama inherent in turning the page, so that each turn reveals a new confrontation between Christ and his persecutors. Through the accumulation of narrative incident and subtleties of characterization, Bening's Christ comes alive. The artist underscores his human side and vulnerability, encouraging the reader to identify with his suffering.

Bening further heightens the drama with the nocturnal setting; many scenes are illuminated, as here, only by torchlight. This scene shows Christ following his betrayal in the Garden of Gethsemane being led before the High Priest Caiaphas. Caiaphas tears his own robes and calls Jesus a blasphemer when he identifies himself as the Messiah. Bening suggests Christ's divinity in his impassive acceptance of his destiny and his physical beauty.

Archbishop Albrecht was a true Renaissance prince in his love of art, learning, and luxury. He commissioned another book from Bening and paintings or graphic arts from the leading German masters Dürer, Grünewald, and Cranach. TK

52 Miniature from a Book of Hours
 Probably Bruges,
 circa 1540–1550

 5.6 x 9.6 cm (2³⁄₁₆ x 3¾ in.)
 Ms. 50; 93.MS.19

 Plate: Attributed to Simon Bening,
 Gathering Twigs

Since the era of the Renaissance, landscape painting has attracted artists and collectors alike. Its appeal, from such masters as Pieter Brueghel the Elder (1525/30–1569) to Claude Monet (1840–1926), is broad. Landscape painting remains one of the most popular attractions of modern museums. The European tradition of landscape painting sprang from a variety of sources, one of the most original and important being the calendar illustrations of late medieval devotional books. Since antiquity the months and seasons of the year were important subjects in art. Artists represented the months symbolically by the zodiacal signs and with figures performing the agricultural labor associated with a particular month, such as sowing or harvesting. In the fifteenth century, book painters showed that illuminations of the settings where the workers toiled, with their distinctive weather conditions, could be even more evocative of a particular month than the labors themselves.

This cutting painted by Simon Bening of Bruges (1483/84–1561), illustrates the gathering of twigs, the "labor" for one of the winter months. It appeared originally in a book of hours in the lower border (called *bas-de-page*) of the page for February in the book's calendar of Church feasts. It shows a damp but sunny winter day. The artist engages our eye not only in the tactile details of the foreground but in the palpable atmosphere that draws us to the middle distance and the gently rolling hills beyond. This diminutive scene is as ambitious in scope and composition as independent paintings of considerably larger dimensions. It is therefore not surprising that the cutting's previous owner admired it as such. Despite its size, he had it framed and hung it on the wall like any other landscape painted on canvas or wood. TK

During the sixteenth century elaborate and inventive calligraphy, or display script, was admired in humanist circles. Intellectuals valued the inventiveness of scribes and the aesthetic qualities of writing. In 1561 and 1562 Georg Bocskay, the Croatian-born court secretary of the Holy Roman Emperor Ferdinand I in Vienna, created this *Model Book of Calligraphy* to demonstrate his unrivaled technical mastery of the immense range of writing styles known to him. He arranged the calligraphy cleverly, giving each page of the book an independent beauty. Indeed, this model book appears not to have been intended originally for painted decoration (even though some pages are written in gold and silver). About thirty years later Joris Hoefnagel, who became a court artist of Ferdinand's grandson, Rudolf II, was asked to illuminate the book. He added fruit and flowers to nearly every page, composing them so as to enhance the unity and balance of the already written pages. The result is one of the most unusual collaborations between scribe and painter in the history of manuscript illumination.

The Antwerp-born Hoefnagel illuminated only six manuscripts, although each was as elaborate as the Getty book and one is said to have required eight years to complete. He also produced countless watercolors of *naturalia,* along with landscapes and city views. He is thus recognized as an influential figure in the emergence of Netherlandish still-life painting in the seventeenth century.

Hoefnagel added to the back of the *Model Book of Calligraphy* some intricately designed pages that instruct the student in the art of constructing the letters of the alphabet in upper- and lowercase. This section has broader, more complex imagery that addresses intellectual and political interests of the court of Rudolf II in Prague. Laden with symbolism, it contains many references to the emperor himself. TK

GLOSSARY

Apocrypha	The Old Testament apocrypha are sacred writings included in the Greek and Latin Bible but not in Hebrew scripture. New Testament apocrypha are early Christian writings proposed but not accepted as part of the Bible.
Cadelle	A capital letter flourished with wide, parallel pen strokes with occasional cross strokes.
Codex	A bound manuscript volume.
Decorated initial	An enlarged, painted letter embellished with non-figural decoration.
Divine office	The prayer liturgy of the Catholic church, consisting primarily of the recitation of psalms and the reading of lessons; divided into eight daily services: Matins, Lauds, Prime, Terce, Sext, None, Vespers, and Compline. The office is recited daily by monks, nuns, and clerics.
Drollery	An amusing or whimsical figure. Drolleries include hybrid figures and usually appear in the margins of manuscripts.
Evangelist	One of the authors of the four Gospel accounts of Christ's life: Saints Matthew, Mark, Luke, and John.
Extender	A decorative enhancement of an initial that continues the letter form into the margin.
Folio	A manuscript leaf. The front side is called the *recto* and the back the *verso*.
Historiated initial	An enlarged, painted letter that contains a narrative scene or identifiable figures.
Humanism	A cultural and intellectual movement inspired in part by the revival of classical learning in the Renaissance.
Icon	The Greek work for "image." In Byzantine culture, an icon (most often in the form of a small painting on panel) carries the likeness of a sacred person or subject to be venerated.
Iconography	The subject matter of an image; also, the study of the meaning of images.
Incipit	The opening words of a text. An incipit page is an elaborately decorated page that introduces a section of text.

Inhabited initial	An enlarged, painted initial containing human figures or animals that cannot be identified specifically.
Laity	The Christian faithful who are not monks, nuns, friars, or members of the clergy.
Liturgy	Public religious ritual.
Mandorla	An almond-shaped aureole surrounding the body of a deity or holy figure.
Mass	The Christian service focused on the sacrament of the Eucharist, in which bread and wine are consecrated and shared.
Miniature	An independent, framed illustration in a manuscript.
Order	A group of people living under a religious rule.
Paleography	The study of historical scripts.
Palette	The range, quality, or use of color.
Parchment or vellum	Prepared animal skin commonly used as the writing surface in manuscripts of the Middle Ages and Renaissance.
Passion of Christ	The sufferings of Jesus leading up to and including the Crucifixion.
Putto (pl. putti)	A nude infant, often with wings.
Scriptorium	A room for the writing of texts; also, a group of people working together to produce manuscripts.
Vernacular	The spoken language of a region, such as French or German, as opposed to an international language, such as Latin or Greek. During the course of the Middle Ages, literature came to be written in the European vernacular languages.

INDEX
Numerals refer to page numbers